A gift from

West Little Rock
Rotary Club

ROTARY
Celebrating 100 years
of community outreach

100 Years
www.rotary.info

D1540967

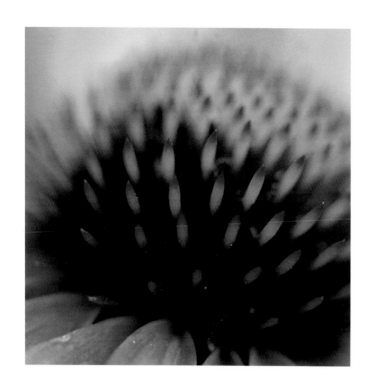

Photographing
flowers

SUE BISHOP

Photographing
flowers

SUE BISHOP

photographers'
pip
institute press

This book is dedicated to my daughters,
Jennifer, Florence and Sylvia, with my love.

First published 2004 by
Photographers' Institute Press / PIP
166 High Street, Lewes
East Sussex BN7 1XU

All text and photographs © Sue Bishop, except author photograph (front cover and page 26): Neil Lindsay;
author photograph (inside flap): Charlie Waite.
All the images in this book can be purchased as prints.
For information, please email Sue at: suebishop.photo@virgin.net

Copyright in the Work © Photographers' Institute Press / PIP

ISBN 1 86108 366 1

Publisher: Paul Richardson
Art Director: Ian Smith
Production Manager: Stuart Poole
Managing Editor: Gerrie Purcell
Commissioning Editor: April McCroskie
Editor: Clare Miller
Art Editor: Gilda Pacitti

Typefaces: Gill Sans and Garamond

Colour origination: Icon Reproduction
Printed and bound: Kyodo Printing, Singapore

Foreword

Throughout history, the mystery and beauty of flowers has been evoked in literature, poetry and painting. From the exotic king proteus in a tropical garden to the humble cowslip in an English meadow, the flower in its many varieties continues to be a source of inspiration for humankind, symbolizing purity, innocence and love.

Through Sue's images, we find ourselves swept away into colourful, abstract worlds. In many of her images, the flower has been used as a metaphor to take us beyond literal understanding, to find new meanings – to become entranced.

Those who read this book will be able to pick up their cameras and borrow from Sue's experience. With simple and easy-to-understand techniques and explanations on the art of flower photography, a wonderful world of colour and creativity is revealed to the reader, enabling them to become lost in making images that will give enormous pleasure, both in the production and the results.

Sue's encouragment and advice on getting the full potential from your camera allows you to join her in creating images that express our wonder of flowers in all of their remarkable variety.

Charlie Waite

Contents

From Document to Art

Introduction

Almost everyone has, at some point, been captivated by the sight of a field of flowers and anyone who owns a camera must have been tempted to try to capture its beauty in a photograph. Flowers, fragile and ephemeral, with their riot of vibrant or pastel colours and infinite variety of shape and form, produce in us when we look at them a deep emotional response. However, images of flowers are everywhere – in advertising, in books, on product packaging – so much so that we have become almost inured to them. So how do we take a photograph that evokes the feelings that we had when we first saw and responded to a flower?

There are two main schools of thought about flower photography. One is that the flower should be rendered completely sharp and shown in proper detail so that it could be identified accurately by a botanist. The other is to try to make a more artistic interpretation, perhaps abandoning some aspects of 'reality' along the way. Both schools of thought are valid, and it is the photographer's choice which way to go, depending on the desired end result. My own preference is for the second way – I have always preferred impressionist and abstract painters to old masters, and for me the same preference holds true in photography.

The photographer must have the necessary technical knowledge in order to create the kind of effect he has in mind, but all the technique in the world will not create a beautiful photograph unless the photographer also has the ability to 'see'.

A photograph selects an area from a whole view – even a sweeping landscape has been extracted from the larger area visible to the eye. Developing the ability to select from all the elements on offer, and to create a pleasing composition out of them, is just as crucial as understanding the different photographic techniques.

In this book I will first of all explain the basics about lenses, filters, exposure and so on necessary to produce a good record picture of a flower, but this is only the starting point. Once this is mastered, the fun part begins – moving from documentation through interpretation to art. In other words, making a photograph that is not a mere record of what you saw, but a creation that produces in you when you look at it the same sort of emotional response that drew you to the flower in the first place.

The photographic techniques should be practised until they become so familiar to you that you can put them to the back of your mind, then you are freed to concentrate on artistic expression. You need to be able to absorb yourself in the subject you are photographing, to focus all your attention on it and respond to it emotionally. Two violinists may play with equal technical competence, but the one who plays with emotion and feeling as well will be the one who reaches the hearts of his listeners. In the same way, the photographer needs to go beyond technical competence to truly see and convey the beauty of a flower, and to produce a photograph which will evoke an emotional response in those who see it.

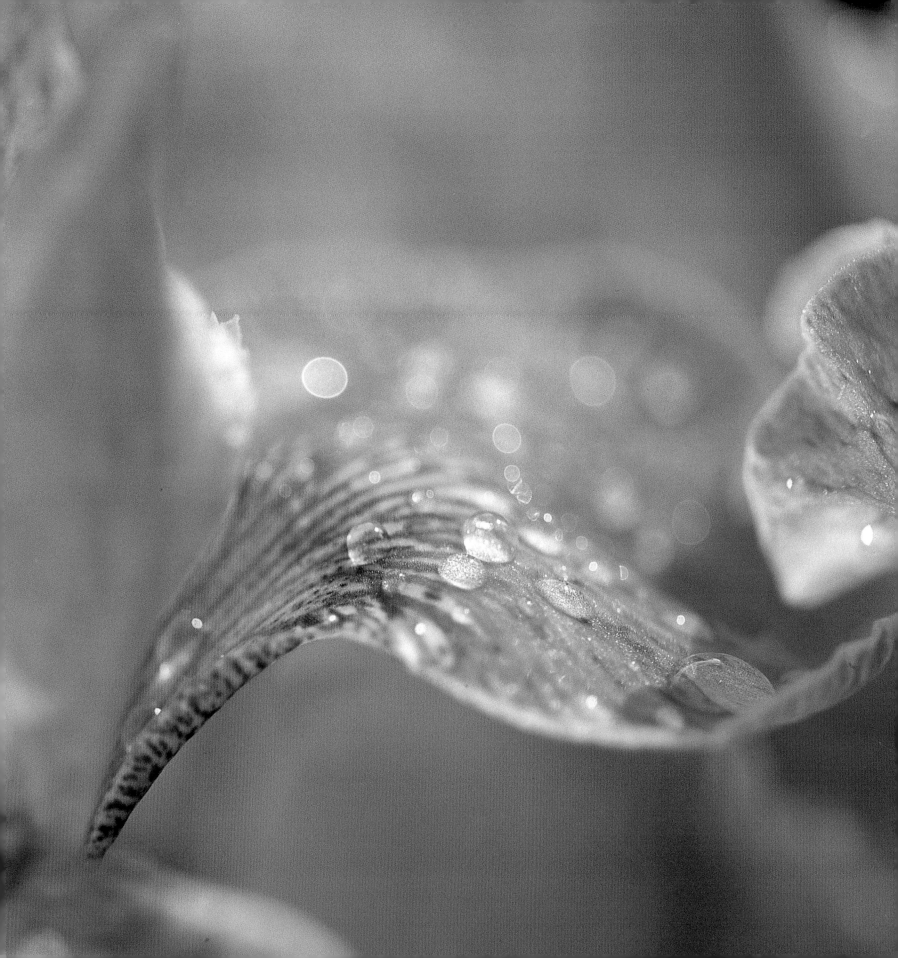

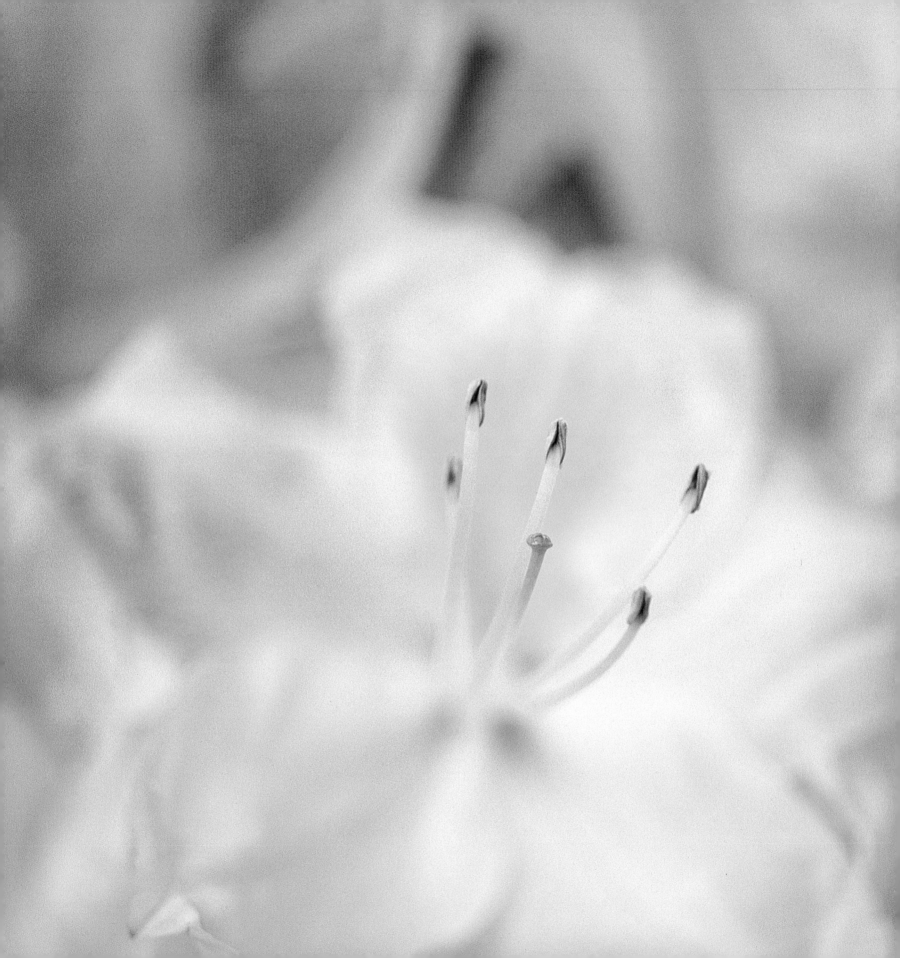

Technical Matters

In any artistic discipline, it is essential to learn the basic techniques in order to have a firm foundation from which your creativity can grow. This section covers equipment, including what to look for when choosing your camera and lenses, and how best to use filters and tripods. It also focuses on that most crucial element in photography, light, with advice on how to control your aperture and shutter speed in order to make a correctly exposed image. Finally this section looks at depth of field, and how to use differential focus in your flower photography.

I t is important for the photographer starting out to consider carefully exactly what he needs and wants before going into the camera store.

Camera equipment is a means to an end, not an end in itself, so don't let yourself be led astray by the temptation of highly sophisticated camera functions which may be something you will never need to use.

Type of camera

It is certainly possible to take pleasing flower photographs with a compact camera, although the lack of interchangeable lenses may restrict the photographer to larger scenes rather than close-ups. For anyone wanting to do closer portraits of plants, a 35mm SLR (single lens reflex) camera is a better choice – one can buy the camera body plus one or more lenses for use in different situations. Beautiful flower photographs can also be taken on medium-format cameras, which produce a larger negative or transparency than 35mm cameras. However, they are bulkier and therefore not so easy to handle for extreme close-ups, especially without a tripod, as well as being considerably more expensive.

One of the first choices to be made when deciding on a camera will be whether to buy a manual or autofocus model. I think I can safely say that all of my flower photography is done using manual focus, although I do use autofocus lenses in other situations, such as more general travel photography. In flower photography, especially when working in close-up or macro mode, the choice of where to focus is very critical, and I prefer to focus manually rather than rely on autofocus sensors picking the right part of the picture to focus on. I also prefer to use a camera that gives the option of aperture priority metering (see Chapter 3). Another useful

function is a depth-of-field preview button, which allows you to see exactly how much of your photograph will be in focus at different apertures (see Chapter 4). Finally, make sure your chosen camera will allow you to override the camera's inbuilt exposure meter, if desired – usually this is done with an exposure compensation button.

Automatic film advance and film rewind are useful, but not strictly necessary for flower photography – they are much more necessary for sports or action photography. They do increase battery consumption and the weight of your camera because larger batteries are required. On the other hand, if you are hand-holding and want to take more than one exposure in exactly the same position, it does help if you don't have to move your hand in order to move the film advance lever.

following pages: **WILDFLOWERS, UMBRIA**

It is possible to buy panoramic cameras, which produce a wider image than usual. This photograph was taken using a Hasselblad Xpan, which uses 35mm film, and can produce an image approximately twice as wide as one taken on a 35mm camera.

An aperture of f/11 provided a reasonable depth of field while still allowing a fast enough shutter speed to prevent blurring from the flowers moving in the breeze.

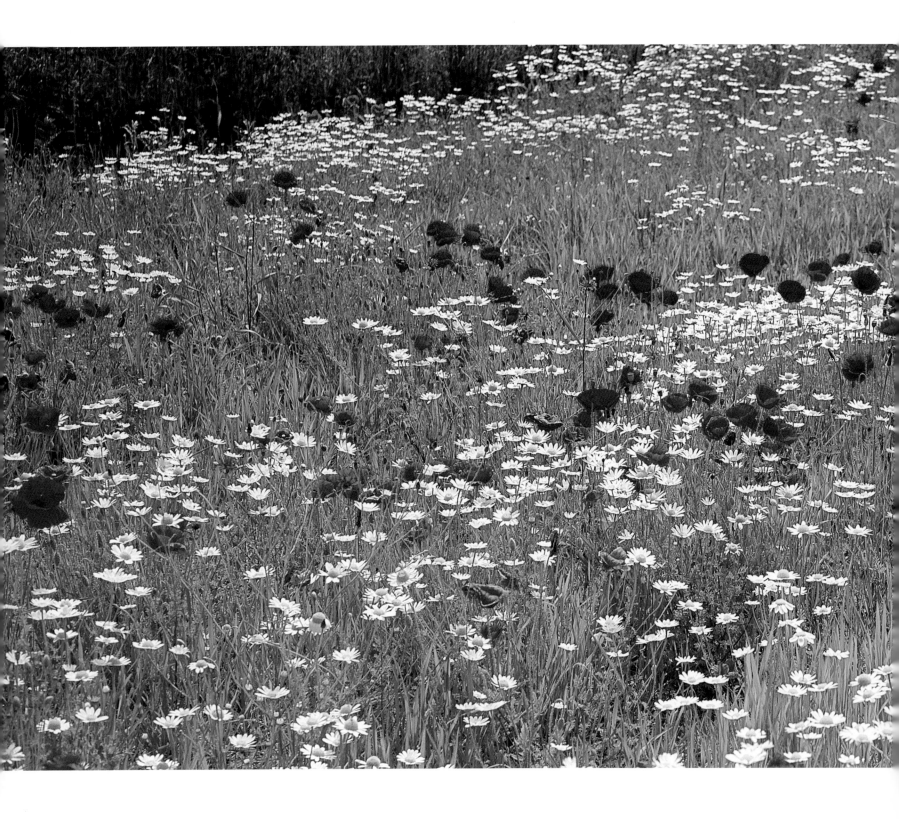

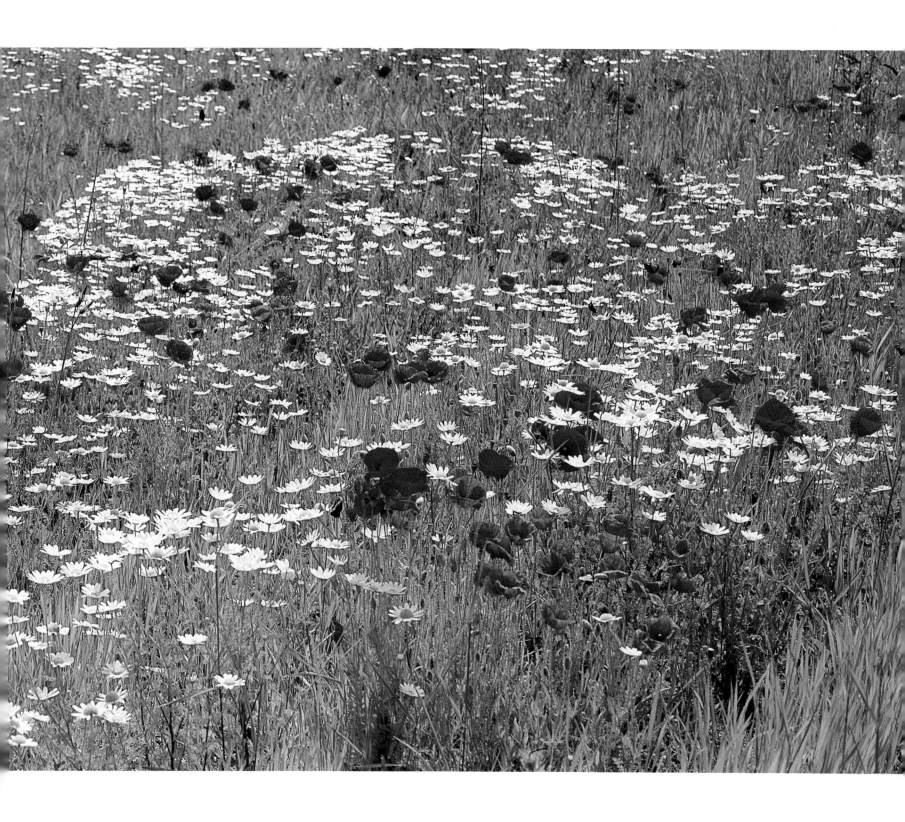

Lenses

Your camera body may well be supplied together with a standard lens. In 35mm photography the standard lens is 50mm, and this is said to see more or less as the human eye sees. Lenses with a focal length greater than 50mm act like a telescope by bringing the subject closer, and are known as telephoto lenses. One can buy medium telephoto lenses (80–200mm), or long telephoto lenses (200–600mm). Lenses with a focal length shorter than 50mm are known as wide-angle, and the shorter the focal length, the wider the field of view they include. The most commonly used wide-angle lenses are between 28mm and 35mm, although wider lenses are also available, right up to an 8mm, which is known as a fish-eye lens.

The lens which is probably of most use to a flower photographer is the macro lens, with a focal length of 50–200mm. A macro lens can act in the same way as an ordinary lens of the same length, but in addition, it can focus much closer than a normal lens. Some macro lenses will produce an image of half life-size on film, and others will give one-to-one magnification, producing a life-size image when used at their closest focus – in other words, a flower one centimetre across in reality will appear one centimetre across on your transparency or negative. I have two macro lenses, 55mm and 200mm, and I use them for about 90% of my flower photography.

PURPLE CONEFLOWER

The use of an extension tube with my 55mm macro lens gave me one-to-one magnification, and enabled me to go in very close and fill the frame with the centre of the flower.

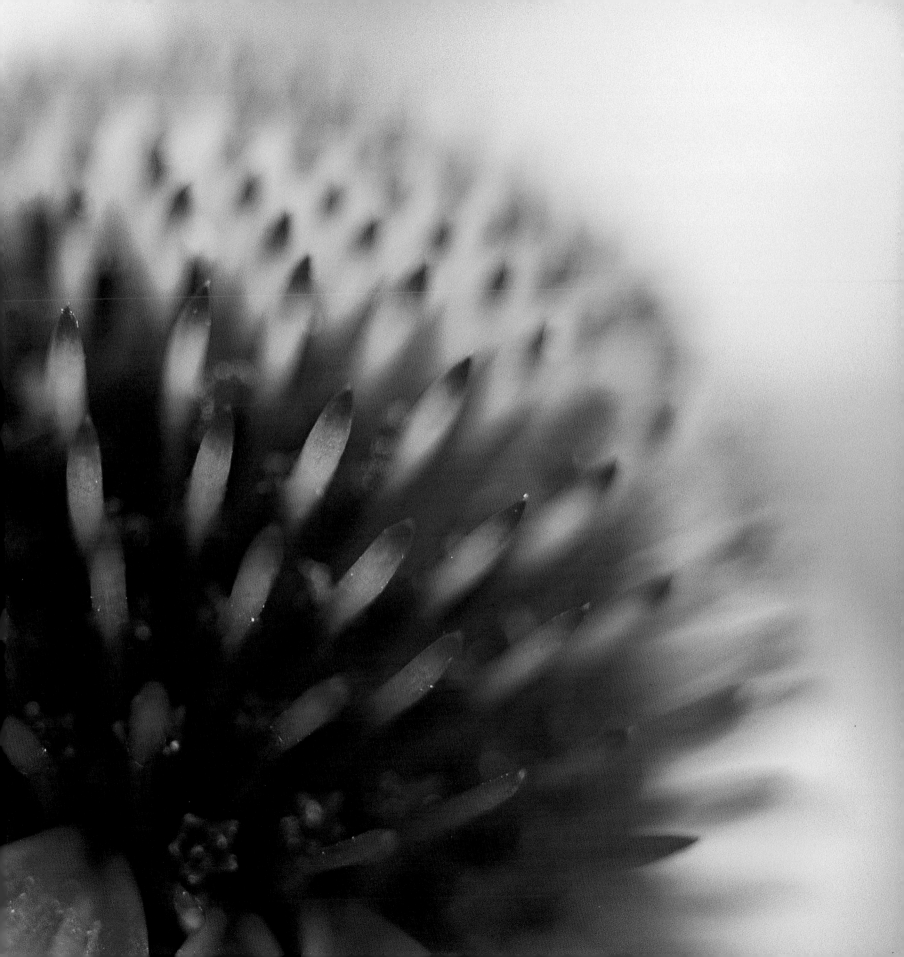

Extension tubes

You can improve the closest focusing distance of your lenses, whether macro or not, by adding extension tubes, which are rigid tubes with no glass in them that fit in between your camera and your lens. These are available in different lengths, and the longer they are, the closer you will be able to focus.

When looking at lenses to buy, you will immediately be faced with another choice – fixed lenses or zoom lenses? Fixed lenses have one focal length, whereas zoom lenses have a range of focal lengths. For instance, a 28–135mm zoom will cover the same field of view as fixed 28mm, 50mm and 135mm lenses, plus all the focal lengths in between. You may wonder why anyone bothers with carrying around several fixed lenses when they could have them all in one zoom lens. Ten or twenty years ago, zoom lenses were not of the same optical quality as fixed lenses, but with modern technology they are generally considered to have reached the same standard. However, many photographers still prefer fixed (or prime) lenses – partly because using them is more of a discipline: one has to think carefully, maybe even move position a little, rather than just standing in the same place zooming in and out until approximately the right composition is reached.

28mm (wide-angle)

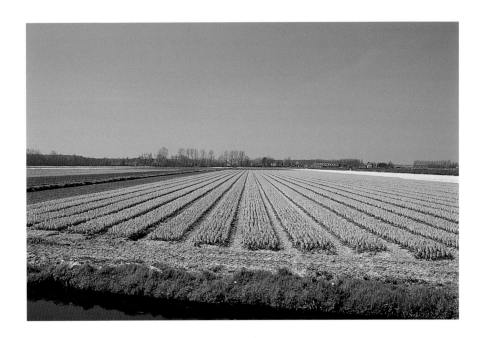

50mm (standard)

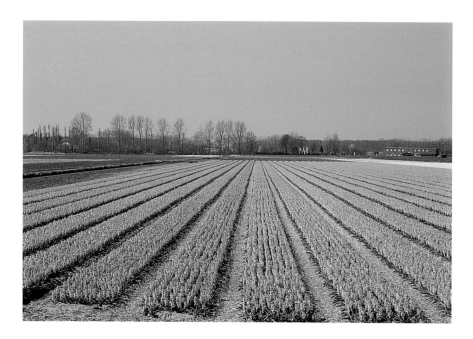

This series of photographs was made with the camera on a tripod – the lenses were changed, but the camera position remained the same for all but the final image. The series was taken to demonstrate the field of view of each of the different lenses.

105mm (short telephoto)

200mm (medium telephoto)

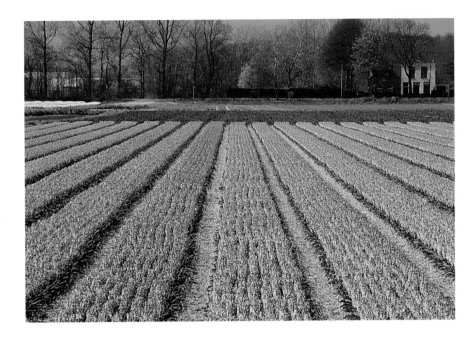

400mm (long telephoto)

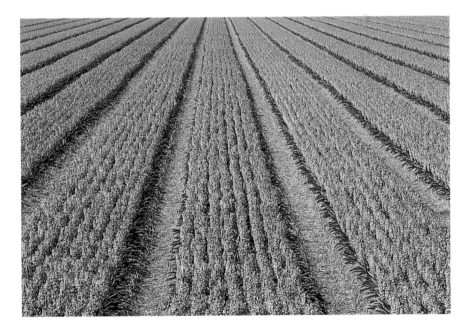

Another photograph taken with the 400mm lens from the same position, but moving the camera down slightly to make a much more graphic image.

Macro facilities on zooms

Although some zoom lenses do have a macro (i.e. close-up) facility, it is not usually a true macro, and does not give the same amount of magnification as a dedicated fixed macro lens. With a few exceptions zoom lenses tend to give a poor performance when used at their widest aperture compared to prime lenses.

Filters and their uses

There is a dazzling array of filters available on the market, with effects ranging from the subtle to the bizarre. Only a small percentage of the filters on offer will probably ever be of use to you as a flower photographer. Probably the three main types you will consider using are the warm-up family of filters, the polarizer, and soft-focus filters. Soft-focus filters are discussed in more detail in Chapter 9, so for now we will concentrate on warm-ups and polarizers.

The most common family of warm-up filters is the 81 series, which ranges from the weakest, the 81A, to the strongest at 81E/F. These are amber-coloured filters which, just as their name implies, warm up your image. You may want to use them when light is cool, either because you are photographing in the middle of the day (see Chapter 2), or because you are photographing in the shade, which film always interprets with a cold or bluish cast. Take care when using them, however! It is very easy when looking through the viewfinder to get carried away and add stronger and stronger warm-up filters, and then find when the photographs are processed that they look far too warm. The use of warm-up filters, as of any

MEADOW IN TUSCANY

The second image here shows a situation when a warm-up filter should not have been used. The attraction of the scene to me was the soft, pastel pink against the green, as seen in the first image. Although the warm-up filter has created a 'sunnier' feel to the second image, it has destroyed the pink and also detracted from the green.

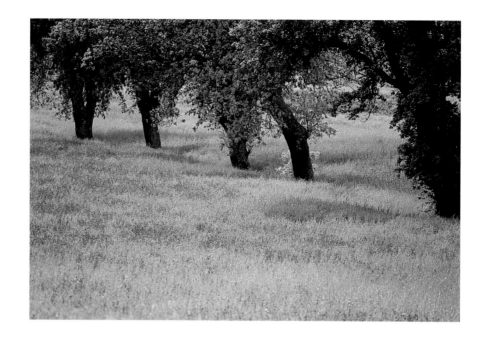

other filters, should be subtle, so that the result looks natural – in other words, you are using the filter as a tool to correct the tendency of the film to record the scene as colder than your eye saw it. People generally respond more to warm images than to cold ones.

Polarizing filters are usually used to enhance skies, particularly blue skies with puffy white clouds, as their effect is to deepen the blue and make it look more dramatic. However, they do also have another benefit – they remove white-light reflection from leaves and foliage, thus intensifying the colour of the leaves. As far as skies are concerned they work best when the sunlight is coming from the side, not from directly behind or in front; in flower photography they will remove white-light reflection from the petals that lie within the plane of polarized light. A polarizing filter does not always have to be used in the fully polarized position – often a half-polarized position will be more subtle and more pleasing. Remember too, that a polarizer intercepts 75% or so of the incoming light, which means that you will need to give more exposure by using a wider aperture or a longer shutter speed, which could cause you a problem in some situations. I only rarely use a polarizer in flower photography, and when I do it is usually on a wider view of flowers in the landscape rather than on a macro shot.

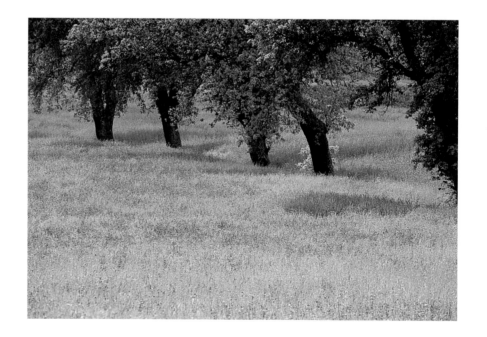

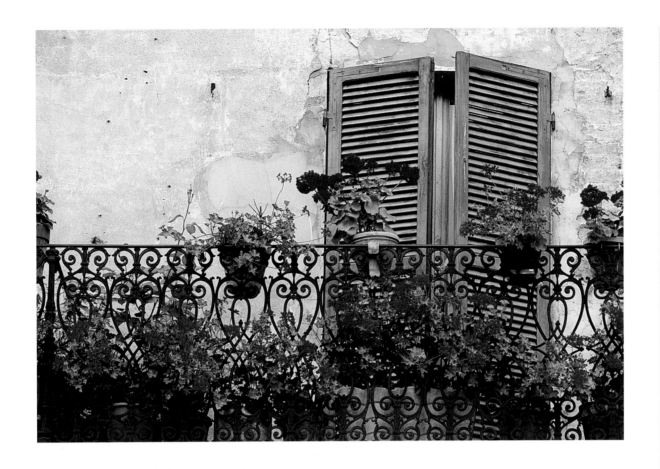

GERANIUMS

This is a composition that did benefit from a warm-up filter. The geraniums on the balcony and the wall behind them were in the shade, which drained some of the warmth out of the colours and gave them a cooler cast. The addition of a warm-up filter when taking a second image (in this case also with a soft focus filter) restored the warmth and glow to the colours.

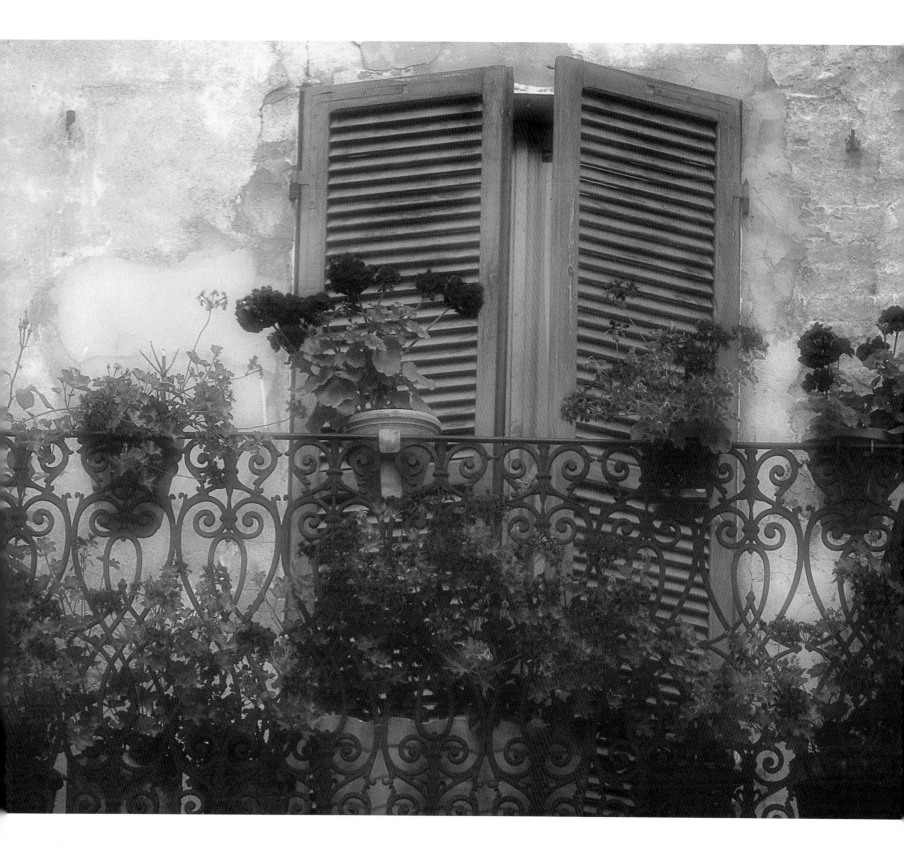

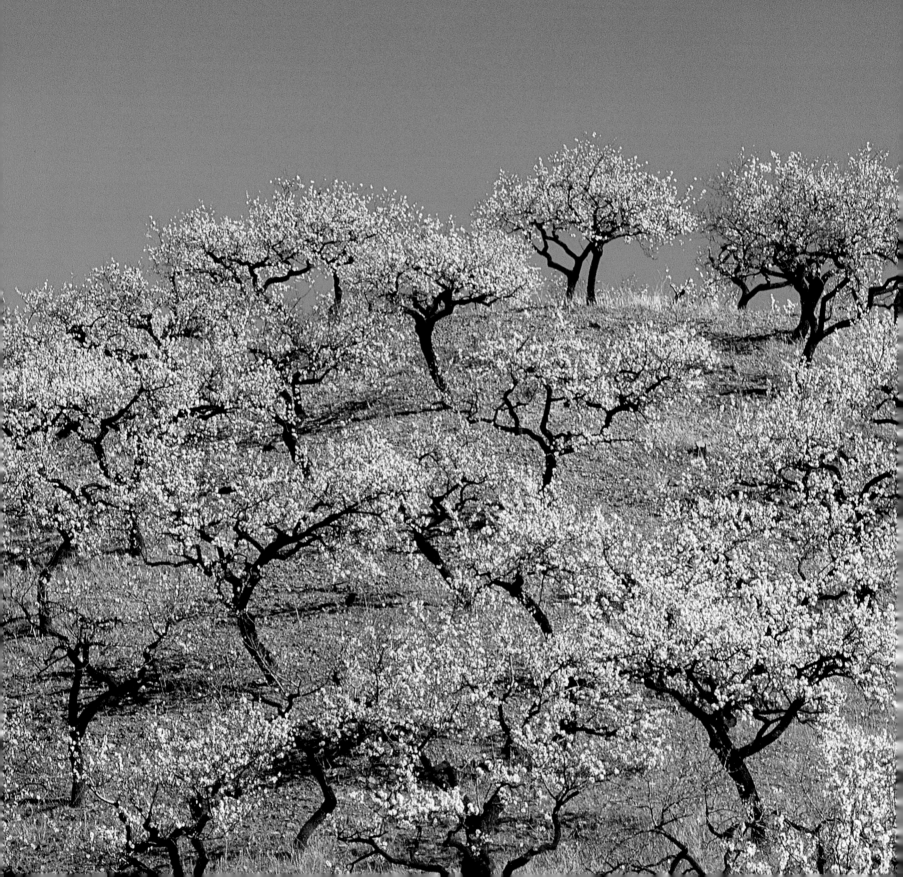

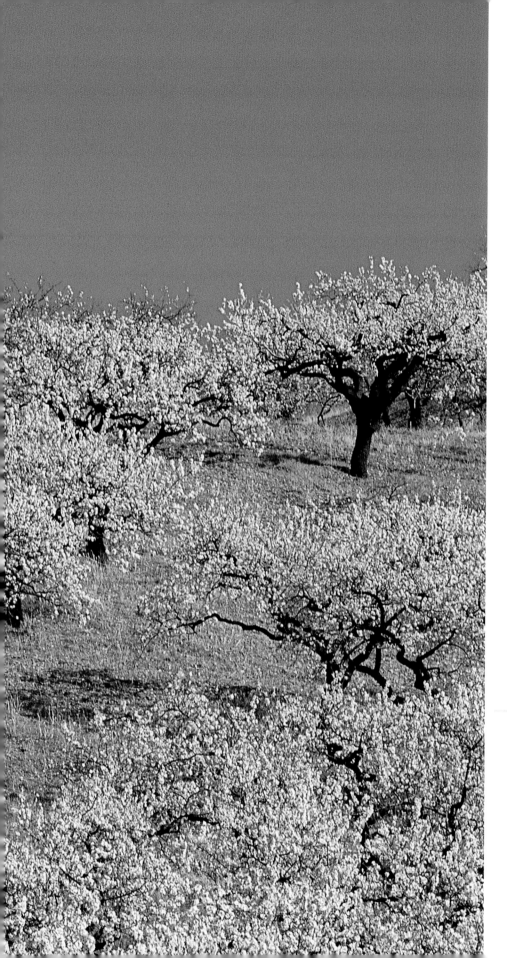

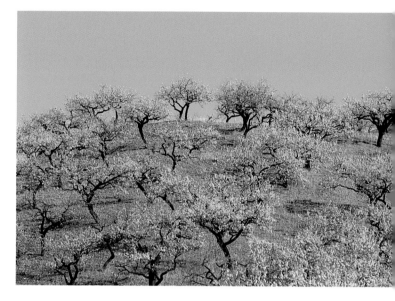

ALMOND TREES

These two photographs clearly show the difference a polarizer can make. The photograph above was taken without any filters, and the one on the left was taken with a polarizer. Not only has the filter dramatically deepened the blue of the sky, it has also given a crisper look to the white of the blossom and the black of the tree trunks.

CHECKING EFFECTS

To determine the effect a polarizing filter will have in any given situation, simply attach the filter to your lens and turn its ring. As you look through the viewfinder you will see the difference as it comes into full polarization and then goes out again.

Using a tripod

Many photographers have a love-hate relationship with their tripod. On the one hand, it is heavy to carry around, and it's not always easy to position it exactly where you want it, especially if you are working at ground level and in macro mode. On the other hand, it has two very definite benefits – as a camera support and as a compositional aid.

The tripod's function as a camera support is necessary in many different kinds of photography. There are situations in which you can hand-hold your camera and achieve a perfectly sharp result, and others in which hand-holding will result in an unsharp image as a result of camera shake. Whether you are able to hand-hold without camera shake or not mainly depends on the shutter speed which you are able to use in the given lighting conditions. This will be explained more fully in Chapter 3.

However, for the purpose of this chapter it's enough to know that if you use a fast shutter speed you will be able to take a sharp hand-held image, but with a slow shutter speed you will not. What is a fast or slow shutter speed in this context partly depends on what lens you are using. As a rough guide, you can assume that you can hand-hold your camera at a shutter speed of 1 over the focal length of your lens – so if you are using a 250mm lens you can hand-hold at 1/250 second or faster, or with a 55mm lens, you can hand-hold at 1/60 second or faster (1/60 being the closest shutter speed to the number 55).

As well as allowing you to take sharp photographs at any shutter speed, tripods are useful as a compositional aid, and this can be particularly important in macro photography, where every tiny movement of the camera can have a considerable effect on the composition because of the subject matter being so close to the lens. With the camera safely settled on the tripod, you can check your subject, your background, and all around the edges of the frame to make sure that your image is composed exactly as you wish, before you press the shutter release.

On occasions when you don't have a tripod with you, it may be possible to gain extra stability by resting your camera on your camera bag or a bean bag, or simply to brace your elbows to keep the camera steady.

Photographing Flowers

WORKING WITH TRIPODS

Using a tripod means that you do not have to be restricted to using fast shutter speeds; instead you will be able to take pin-sharp photographs at shutter speeds as slow as you need in any given lighting situation.

Having said all this, there are still occasions when I hand-hold my camera – sometimes if I am working with the camera only a millimetre or so from the nearest petal tip, and there are restrictions on where I can put my tripod legs without damaging other plants, I will give in and work without the tripod.

Certain types of tripod are much better suited to flower photography than others. You should make sure you choose one which can go right down to ground level – Benbo and Gitzo both make good tripods for this purpose. Also make sure the tripod head is really designed for photography rather than for video use, as some tripods are supplied with video heads which do not have a full range of movements.

Choice of film

Unless you are shooting digitally, you will have to choose whether to use transparency film (for slides) or negative film (for prints). There are pros and cons for both, and your decision will largely depend on the end use you have in view for your photographs. If you hope at any stage to have your work published in magazines or books, or sold commercially through a photo library, then you should use transparency film, as this is the preference of 90% of editors and photo buyers. By using transparency film you are not precluding yourself from having prints made from your photographs, as this can still be done, although it would become expensive to have prints made from each image on the film. If you don't have any ambitions to publish your photographs, but love to be able to show them to other people as small prints, or to display them as larger framed prints on the wall, then you will probably choose to use negative film instead. Negative film also has the bonus that it is more forgiving of exposure errors than transparency film!

Having decided between negative and transparency film, your next choice is what film speed to use. Films are described as being fast or slow, and this is explained in more detail in Chapter 3. For the vast majority of my flower photography I prefer slow film, which gives very fine grain and saturated colours. The choice between the green and yellow giants, Fuji and Kodak, is more of a personal one. Each film make has a slightly different colour balance, and the only way of really finding out which one you prefer is to shoot a roll of each in the same location at the same time, and then to compare the results afterwards. My own favourite, and the film which I have used for the majority of the photographs in this book, is Fuji Velvia.

2

LIGHTING

An awareness of the different qualities of light is vital in any photographic endeavour. Light can come from in front of the photographer, from the side or from behind. It can be hard or soft; it can be warm or cool. The shadows thrown by the light can be long or short, hard or soft, or there may be none at all. The quality of light can make or break a photograph – a fairly mundane subject can be transformed by beautiful lighting into something transcendent, but by the same token a photograph of an attractive subject taken in the wrong lighting conditions may not be a successful image.

The direction of the light

Assuming that you are working in sunlight rather than overcast conditions, then the direction of the light in relation to the subject will need to be considered. Imagine that you are photographing a single flower in the middle of a field, with nothing to prevent you from moving around it and working from any side you choose. First you may stand with the sun at your back, so that it is falling directly onto the flower from behind you. This will give good colour saturation to the petals, but will not reveal any texture that may be there because it is falling flatly onto them. It will evenly illuminate all that part of the flower that is facing towards you. Next imagine moving round 90° so that the sun is coming from your right side, and hitting the right side of the flower as you look at it. Now this side of the flower will be more brightly lit than the left side, and any texture that is in the petals will be revealed by the light skimming across their surface. Finally, move another quarter circle so that the flower is now between you and the sun. The backlighting will create an entirely different mood in your image from

AVOIDING FLARE

Take care when photographing into the sun that you don't allow sunlight to fall directly onto the front of your lens, as this will cause flare in your final image.

the front or side lighting. If the petals are at all translucent, the sun will glow through them from behind, and indeed backlighting works better on flowers with translucent petals, such as poppies, than on flowers with heavier or darker petals.

In order to avoid flare (patches of bright light in your image) if your camera is on a tripod, stand to one side of it and shade the lens with your hand or a piece of card while you take the photograph. Some lenses are supplied with lens hoods that will also help to shade the lens, but don't just rely on them without checking to see that they really are shading the lens completely.

Working with light

There is no rule that says that one type of light will always be better than another – each subject or situation will need to be evaluated by the photographer to decide whether the prevailing light conditions are detracting from the subject or enhancing it.

Photographing Flowers

NAMAQUALAND DAISY

The use of backlighting together with a soft-focus filter has given a warm glow to the translucent petals of this flower.

An aperture of f/4 and careful focusing have isolated my chosen flower against a background of other flowers thrown out of focus

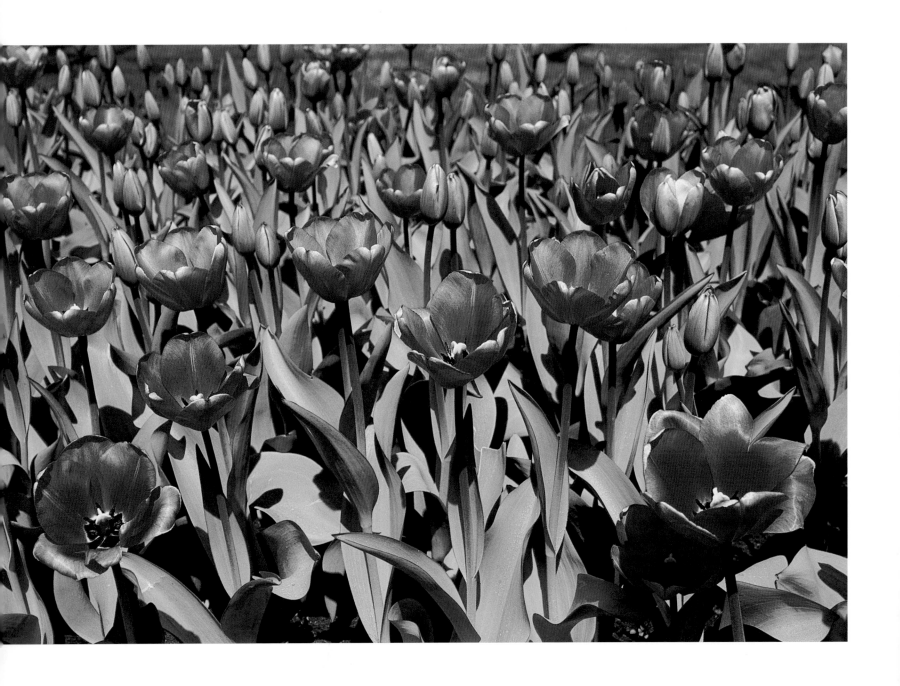

Photographing Flowers

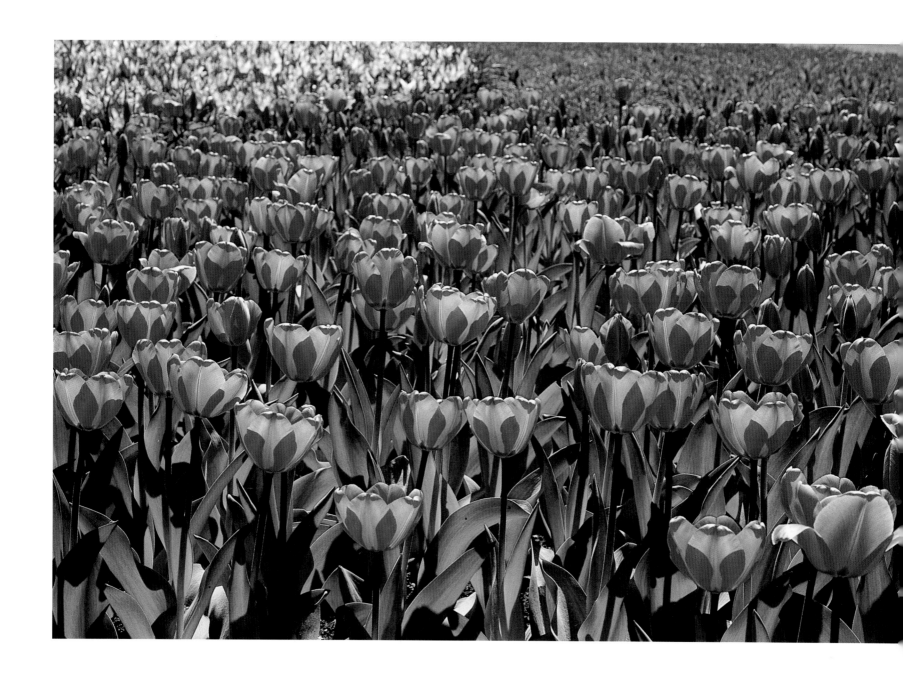

TULIPS

In the first of these photographs the tulips are front-lit, and in the second they are back-lit. The effect is very different, both on the petals and on the leaves. The back-lit image has a much greater sense of vibrancy and life. The back-lighting has also revealed a pleasing pattern where the petals overlap each other.

The first shot was taken at the camera's suggested reading. For the second shot I added half a stop of exposure to allow for the effect of the backlighting

Photographing in sunlight

Bright sunlight has advantages and disadvantages when it comes to flower photography. The warmth of the sunlight can intensify and saturate the colours of a flower; but the presence of light brings with it the presence of shadows, and a hard shadow cast by one petal onto another will almost always be unsightly in your final image.

When you look at a scene without a camera, your eye and brain compensate for the highlights and the shadows and show you the detail that is there both in areas that are lit and those that are shadowed. However, the camera and film cannot cope with the same range of light and shadow as the human eye, and if the range of light and dark is too wide, then it cannot record both. As a result you will either have correctly exposed highlights and dark shadows with no detail, or detail in the shadowed areas but with burnt-out highlights.

Reflectors and diffusers

There are ways to work around this if you are working in close-up, in particular with the use of reflectors or diffusers. A reflector is a sheet of white, silver or gold which is held on the opposite side of the flower from the sun, and reflects some of the sun's light back into the shadow areas. These can easily be made by using a sheet of white card, or silver foil crumpled up, spread out again and glued onto cardboard. Gold foil will provide a warmer reflected light. A diffuser is a piece of material such as white chiffon stretched over a frame, or a white umbrella, which is held between the sun and the flower and softens or diffuses the sunlight before it falls onto the plant.

Time of day

The time of day will also have an effect on the light – at midday the light will have a cool or bluish cast, whereas early or late in the day it will have a warm, golden cast. It can be an interesting experiment to photograph the same white flower early in the morning, again at midday, and again in the last light of the afternoon, without using any filters – the white of the petals will be much cooler (more blue) in the photograph taken at midday than in the images taken early and late in the day. Neither is necessarily right or wrong, but you need to be aware of how the light at different times of day will affect your colours. This will enable you to shoot at the right time to achieve the result you want, or if this is not possible, to compensate for any colour casts by using filters.

RHODODENDRON

Delicate, pastel-coloured flowers are often better photographed in overcast light. I photographed this rhododendron in sunlight, and then in overcast light when the sun went behind a cloud. I think the second version is more successful, with the even lighting enhancing the delicate petals. In the first version the sun has caused contrast and shadows which distract the eye.

A macro lens was used in order to fill the frame with the petals.

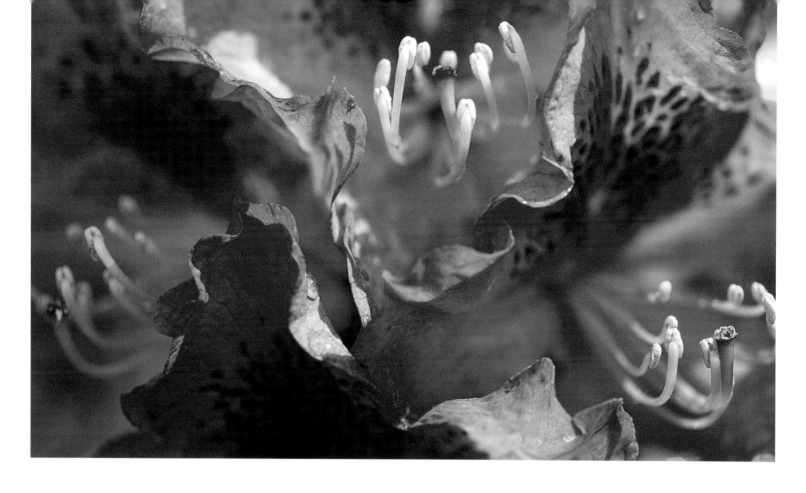
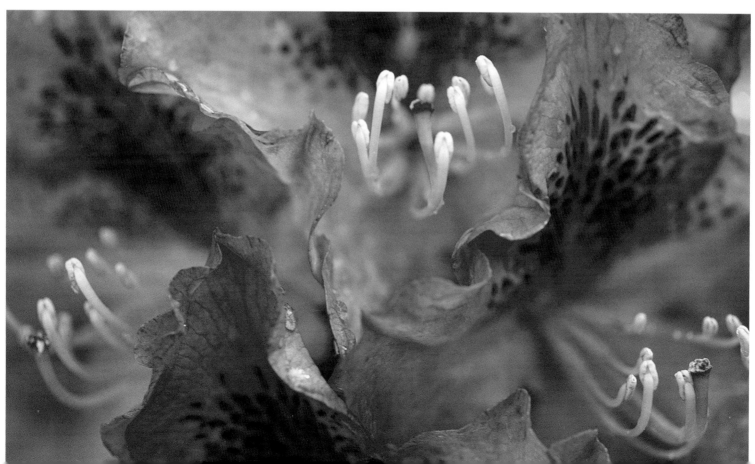

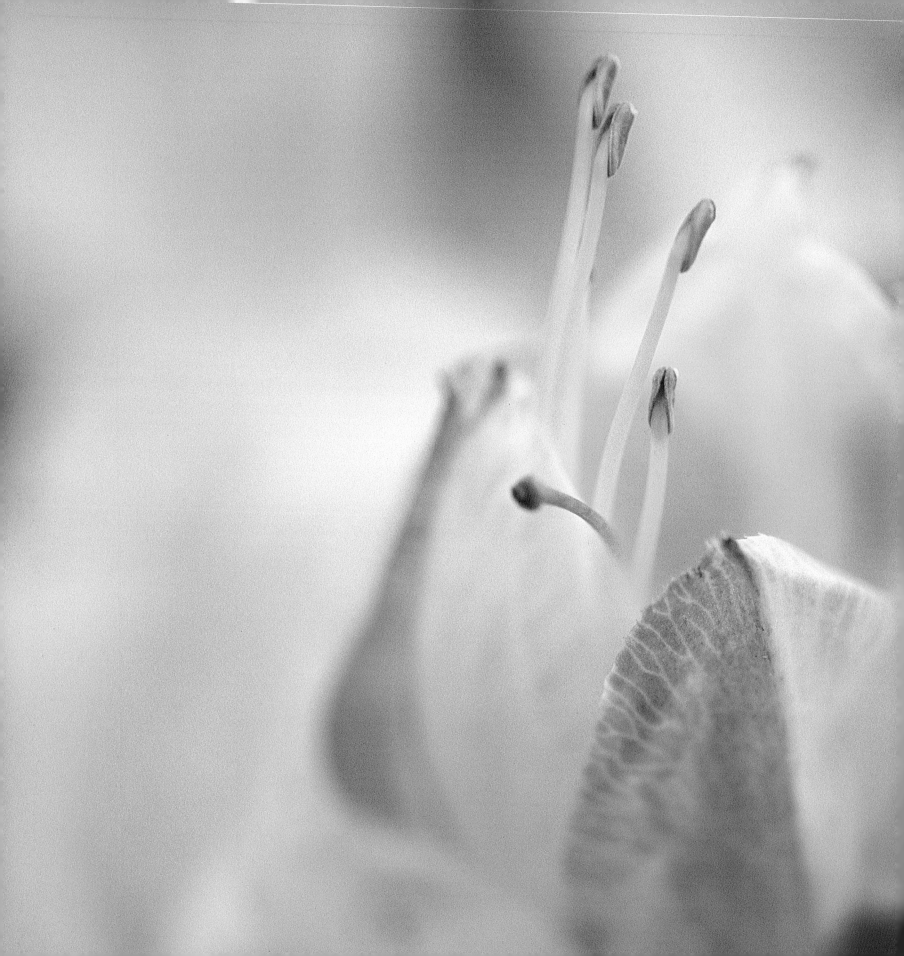

Photographing in overcast conditions

Probably the optimum light for flower photography is 'bright overcast', when there is a thin layer of cloud, enough to act as a giant diffuser for the sun, but not so thick that there appears to be no sunlight at all. This will eliminate the problem of shadows, while still giving the image a bright rather than a dull feel. You will be able to record the subtleties of colour and tone much more effectively than you could in bright sunlight.

Photographing in open shade on a sunny day will produce a similar effect, but beware that the light from the blue sky reflected into the shaded areas will produce a blue, cold cast. This can easily be corrected by careful use of a warm-up filter.

AZALEA

The even lighting of an overcast day was perfect for photographing this azalea bud, enhancing its delicate variations of soft colour.

In this case, I used an extension tube with my macro lens

SUNFLOWER

Some flowers are better photographed in bright sun, and the sunflower is a good example. It is a bright, vibrant colour, and the shape is bold rather then delicate. The sun enhances the radiance of the yellow without any of the negative effects sometimes experienced with more delicate flowers.

I used a telephoto lens (300mm) to isolate part of one flower against the background of another bloom thrown out of focus

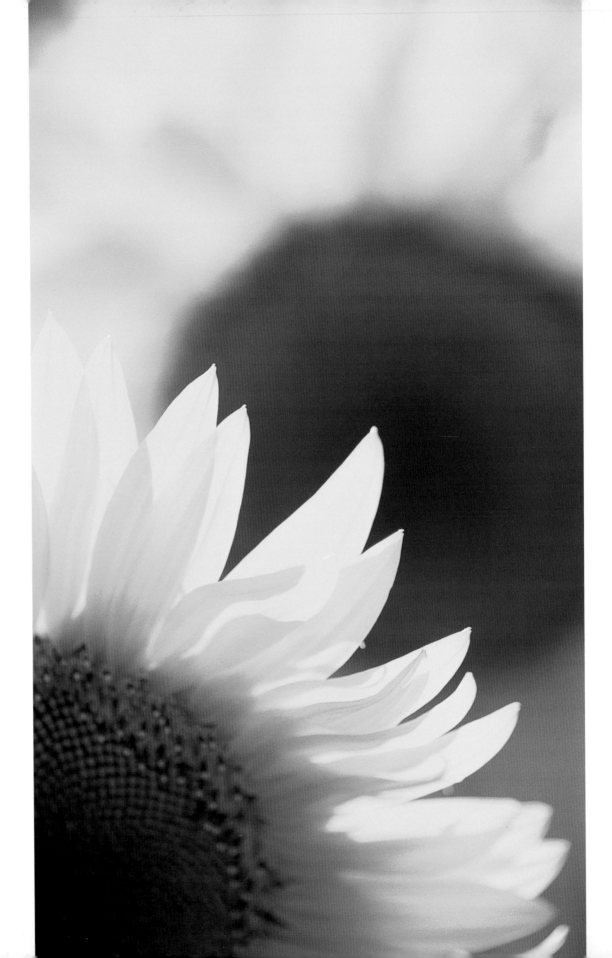

Using flash

Some photographers will choose to use flash when photographing flowers. Generally the flash is used at less than full power, and this is known as fill-in flash. In conditions where bright sunlight is causing harsh shadows, the fill-in flash will literally fill in the shadowed areas with light. However, great care needs to be taken so that the resulting image still looks natural. In particular, if the flower is lit by the flash but the background is not, you may end up with a very dark or even black background, which looks unnatural and, in my view, unattractive.

Flash effects

Flash for me is a last resort – although it will light your subject evenly and remove unsightly shadows, it may also remove mood and atmosphere from your image.

ORCHID

The light was so dim in the glasshouse in which this orchid was growing that a photograph by natural light only would have appeared rather dull and lifeless. For this reason I chose to use fill-in flash. In the resulting image the flowers themselves look crisp and bright, but because the flash has not illuminated the background it has gone dark and does not look natural.

A short telephoto lens (135mm) was sufficient to fill the frame with a single flower

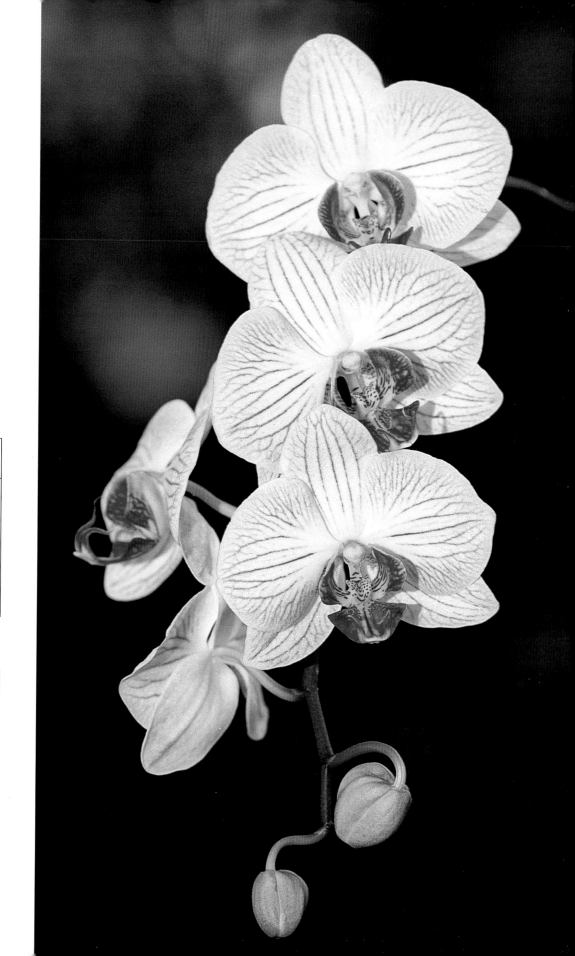

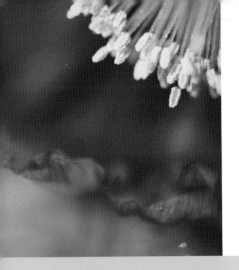

Another variety of poppy provided a session of photography in my kitchen, using only daylight coming through the windows. I didn't want to make a straightforward picture of the poppies arranged in a vase with an artificial background, so I knew that I needed to go in so close that any background was excluded. I moved around the flowers looking through the viewfinder all the time, seeing how they looked from various different angles.

CASE STUDY 1: Poppies from the florist

I decided that I liked the slightly crinkled texture of the petals, so focusing on that I made a very close-up, abstract image of a pink flower against a background of other flowers thrown out of focus (right). I then placed one of the flowers on a sheet of ordinary kitchen foil on my table, and photographed part of one of the poppies with its own reflection and the reflections of some of the other flowers which were laid behind and above it.

An abstract close-up of one poppy using a very shallow depth of field

Location:
My kitchen

Time of year:
July

Camera:
Nikon F100

Film:
Fuji Velvia

Lenses:
55mm macro lens, some with extension tube

Filters:
81B warm-up

Using reflection
Working with the foil was fun as the pattern of colours changed as I changed my angle, and it allowed me to photograph as much or as little of my main subject as I liked without worrying about an unrelated background distracting from it.

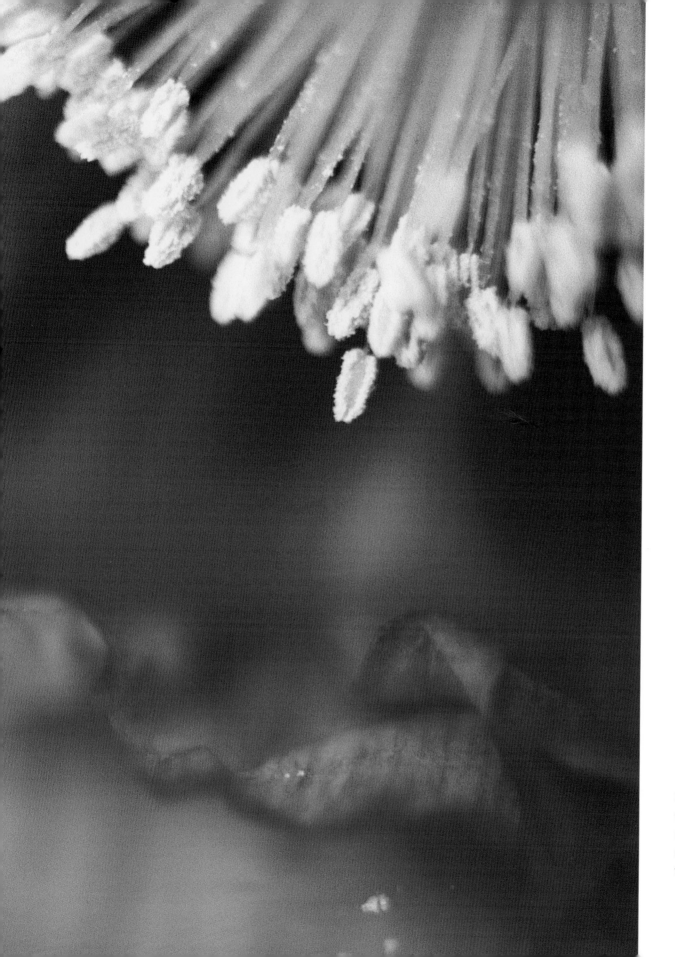

Using only part of one flower, this photograph made use of the reflections of several flowers in some silver foil.

In the end, however, my favourite images were the ones focusing on the beautiful yellow stamens. For these I laid the poppies on a table and, with the lens at its closest focusing distance, moved the camera in and out until the sharp point of focus was exactly where I wanted it on the stamens.

Because I was working at such close range, the end of my lens sometimes touched the edge of the petals nearest to me, so working with the flowers on a table instead of in a vase gave them more stability and meant that they didn't move every time my camera touched them. I made photographs in both portrait and landscape formats, focusing on the stamens nearest to me and using a wide aperture to allow everything else to go out of focus.

Focusing on the nearest stamens with my widest aperture allowed the rest of the flower to go out of focus and become a blend of lovely warm colours. I made sure that no unrelated background showed behind the poppy by putting other flowers behind it to fill any gaps.

Case study 1: Poppies from the florist

EXPOSURE

Most cameras manufactured in the last few years will calculate your exposure for you and as a result, many people never fully understand the principles of exposure. However, although the camera may produce acceptable results on many occasions, on other occasions the resulting image will not be as good as you would wish it to be, and you will not be able to improve this or rise above it unless you understand about exposure and how to control it. This is not nearly as difficult as you might think! Once you understand the basic relationship between aperture and shutter speed, and how they in turn relate to film speed, then everything falls into place.

A correctly exposed photograph is one where the camera allows in just the right amount of light to make an image on film where there is detail in both highlights and shadow areas. There are two ways in which you can control the amount of light which enters the camera – by changing the aperture and by changing the shutter speed. The aperture is a diaphragm inside the lens which can vary the size of the circle through which the light will enter. At any given shutter speed, a wider aperture will allow more light to enter than a smaller one. The apertures are designated by the f-stops on your camera, and, rather confusingly, the larger the number of the f-stop, the smaller the aperture is. Thus when you have your camera set to f22 you will have a small aperture, and when it is set to f4 you will have a wide one.

If you allow your camera to make the exposure decisions for you, it may not make the right choice for the effect you are aiming to achieve. For

Shutter speeds

The shutter is a curtain that opens and shuts at the moment you press the shutter release. At any given aperture, a fast shutter speed will let in less light than a slow one. Shutter speeds are expressed in seconds or fractions of a second.

instance, your photograph may be of a beautiful flower with a rather unattractive background. In this case you will want to make the flower stand out in sharp focus, and throw the background out of focus. This is explained more fully in Chapter 4, but for now let's say that to do this you will need to use an aperture of f4. Your camera may have chosen an aperture of f11 with a shutter speed of 1/60 second. Now comes the part where you take control!

Using aperture priority

Many cameras offer two alternative options to totally automatic exposure – aperture priority and shutter speed priority. I find that for flower photography aperture priority is the more useful of these. In this mode, you can choose the aperture that you want, and the camera will give you the correct shutter speed for that aperture. So now you are looking at your flower, and you set your camera to aperture priority metering, then set your aperture to f4. This will give you the effect you wanted as far as aperture is concerned, and the camera will automatically set the correct shutter speed. You have set an aperture of f4 instead of f11, which is a difference of three stops (f4 to f5.6, to f8, to f11). The camera will have

adjusted your shutter speed by three stops as well, so that the resulting exposure is the same – in this case the shutter speed will have changed from 1/60 second to 1/500 second.

In order to achieve the same resulting exposure, every time you allow one stop more light in by opening up your aperture by one stop, you will need to allow one stop less light in by making your shutter speed one stop faster. Similarly if you close down your aperture by one stop, you need to make your shutter speed one stop slower.

The other factor in this equation is the film speed, which is designated by the ISO rating of your film. A film with an ISO of 50 is one stop slower than a film with a rating of 100. So an exposure setting that will give you a correctly exposed image on a 100 ISO film will have to be increased by one stop to give you the same correct exposure on a 50 ISO film. If you have TTL (through the lens) metering, your camera will automatically adjust to give the right readings for the film being used, once you have set

EXPOSURE

In the case of flower photography, it is generally more likely that any exposure error will be on the side of underexposure, as you will not often be photographing a subject so dark that the camera tries to lighten it to achieve a mid-tone result. The problem will most usually occur when you are photographing white or other light-coloured flowers, and the camera underexposes them because it thinks they must be a mid-tone.

the film speed on the film speed dial. Most modern 35mm cameras automatically detect the speed of the film being used (the DX coding system) and make the exposure readings accordingly.

It's also useful to understand the way in which the camera's TTL meter works, as there will be times when a given situation will fool the meter and the result will be an image which is either overexposed or underexposed. Basically, the camera's meter tries to reproduce everything as 18% grey, which is an average mid-tone. In a general view without any unusual lighting, this result will usually be correct. However, if you are looking at a very light scene such as a snow-covered landscape, the meter will still try to make a mid-tone result, so that your snow will come out underexposed and grey. Similarly, if you are photographing detail on a very dark rock, the meter will try to give a mid-tone result, and your rock will come out lighter in the photograph than it really was. In situations like this, when your main subject is considerably lighter or darker than an average tone, you may have to override the camera's exposure meter.

When working in aperture priority mode, you can do this by using your camera's exposure compensation dial. This will allow you to add to or subtract from the amount of light that the meter thinks would be correct. Exposure compensation dials or buttons are usually marked in either one-third or one-half stops. In the case of the snow scene, the camera thinks that the white must be a grey, and so does not allow in enough light, so you will need to add a stop or even two stops of exposure. If your subject is brightly back-lit you will often need to add exposure in order to retain colour

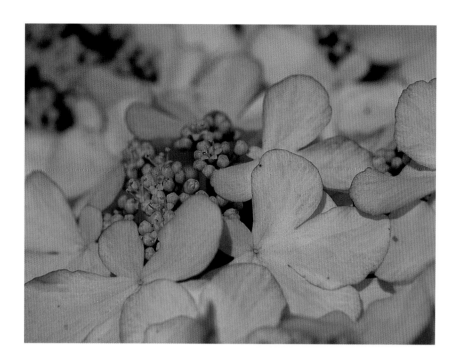

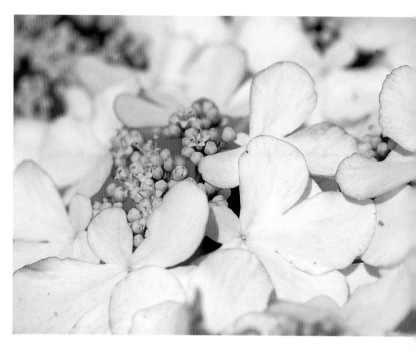

and detail in the subject. When you are photographing a very dark subject, you will need to dial in a minus amount of exposure compensation.

The first factor you will need to consider when deciding whether you need to add exposure compensation is how much of your image is devoted to the white or light colour. If you are photographing just one white bloom, and it is fairly small in the frame with a background of mid-tone green, the chances are that your camera's suggested exposure will be the correct one. The larger the proportion of white in your image, the more exposure compensation you will need to add, so that if your entire frame was filled with white petals, you might need to add as much as one and a half stops of extra exposure. There is no sure-fire scientific formula for this, but with experience you will start to know which photographs are likely to work at your camera's suggested reading and which

are not. If in doubt, and you think you have found a good image, you can bracket your exposures. This means that you take your first frame at the exposure the camera suggests, and then take two more frames at half a stop or a stop on either side of that reading. Alternatively, if you know more exposure is needed but are not sure how much, bracket by adding half a stop, one stop or even one-and-a-half stops.

VIBURNUM

The first of these photographs was taken at the camera's suggested reading – the result is that the meter has been fooled by the white, and has reproduced it as grey. For the second photograph I increased the exposure by one stop, which has given a better result.

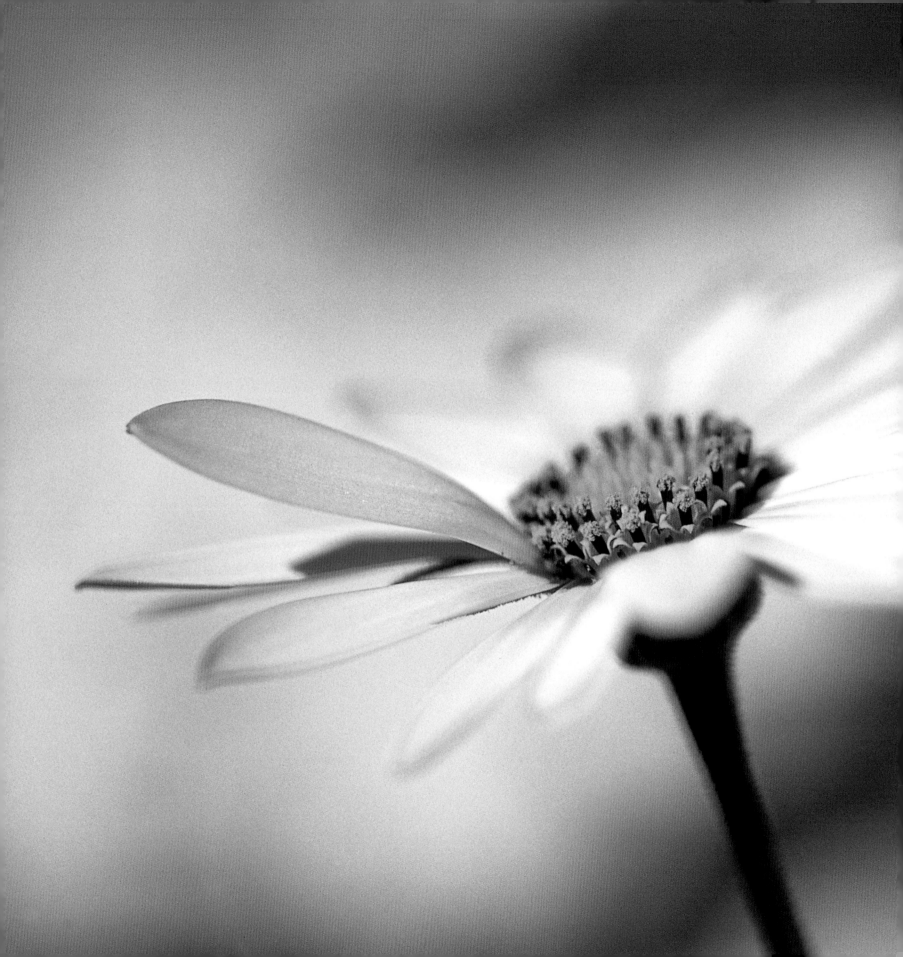

WHITE DAISY, NAMAQUALAND

This was a clear case for exposure compensation, since the frame was almost entirely filled with white. This photograph was taken at about one and a half stops over the camera's suggested exposure.

A macro lens and extension tube were used in order to fill the frame with a single flower

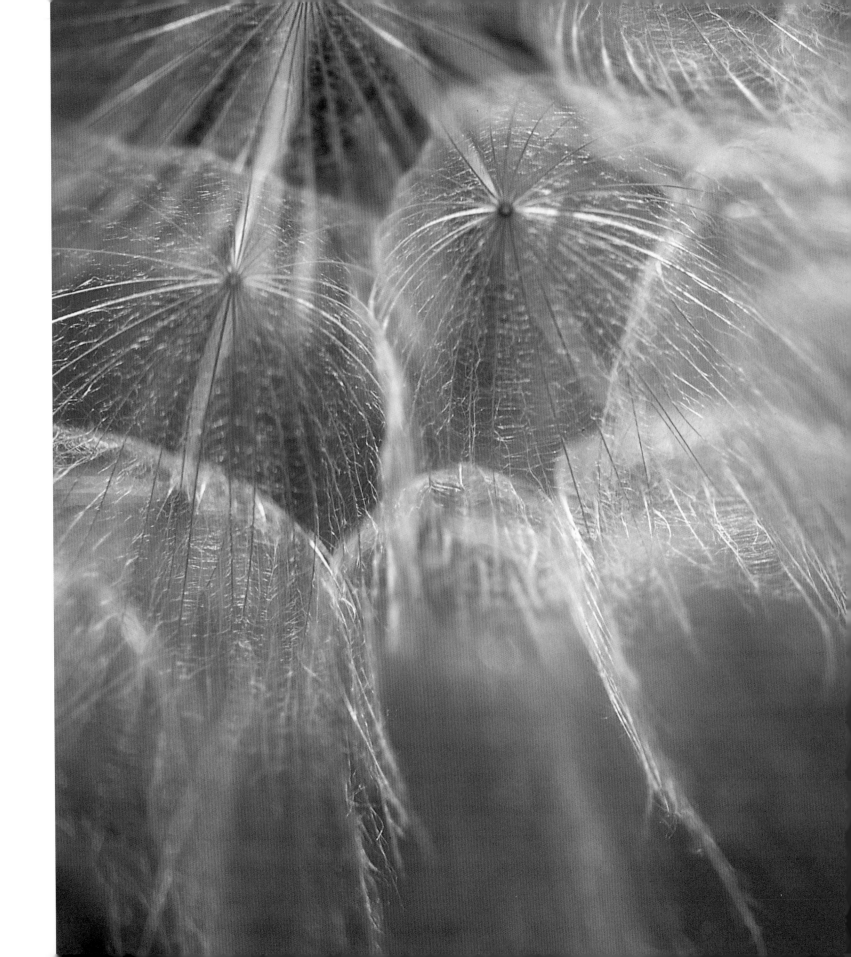

SEEDHEAD

This seedhead was not only white but also softly back-lit, so I added exposure using the exposure compensation button. Because half the image was made up of darker tones, however, I only had to add about half a stop – had the whole frame been taken up with the seedhead I would have had to add more than that.

I needed a fast shutter speed (1/125sec) to freeze any wind movement in the delicate seedhead

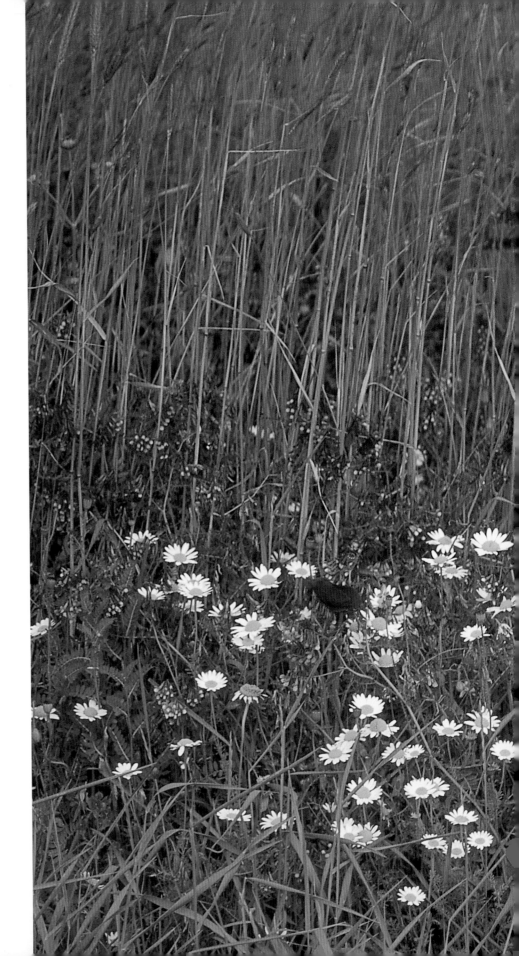

WILDFLOWERS AND GRASSES

Although there are a few white flowers in this image, it is predominantly made up of mid-tones, and so there was no need for any exposure compensation – the camera's suggested reading produced the correct result.

I waited for a cloud to cover the sun, as these delicate flowers looked better in soft light

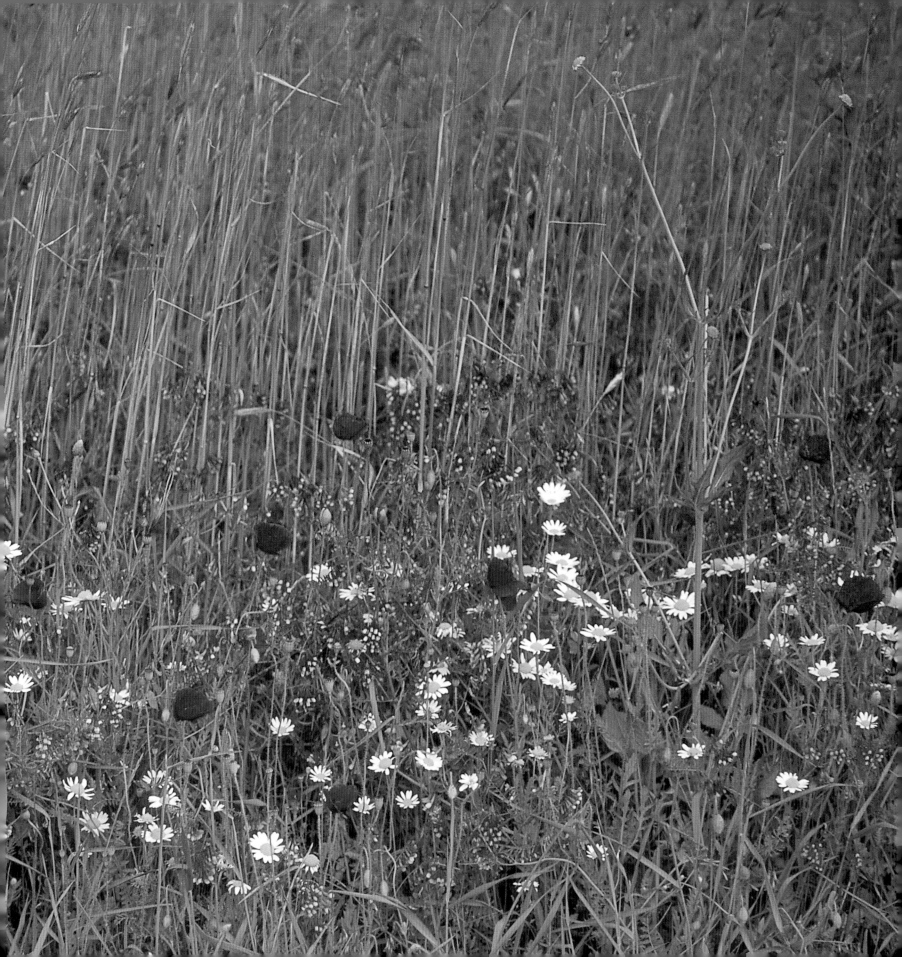

UNDERSTANDING
DEPTH OF FIELD

HIBISCUS

This series of photographs shows the effect that changing your aperture can have on the background of your subject. The camera was on a tripod, and the only thing that I changed between each photograph was the aperture. Because the camera was on aperture priority exposure mode, it automatically changed the shutter speed as I changed the aperture. At f32 the background is a messy jumble of foliage; at f4 this has gone so far out of focus that it becomes a pleasant wash of green which no longer distracts attention from the hibiscus flower.

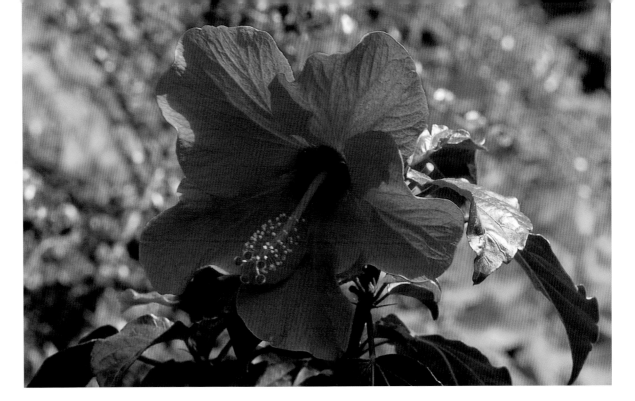

f32

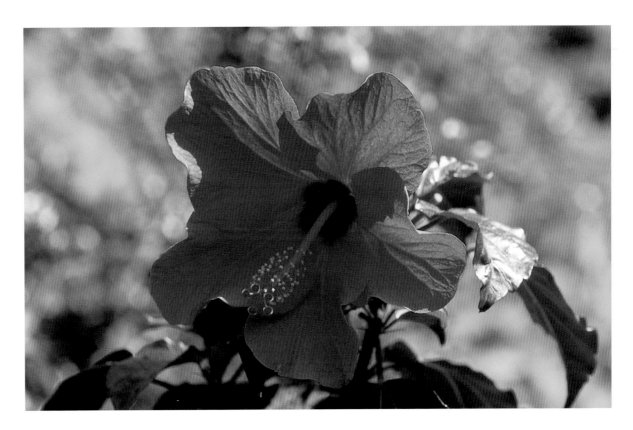

f16

If you photograph the same subject from the same place with different lenses, a lens with a long focal length will give you a shallower depth of field than a lens with a shorter focal length. For instance, if you focus on a tree with a 300mm lens, you will have a much shallower depth of field than you would if you photographed the same tree from the same position with a 50mm lens. This leads to an assumption that longer focal length lenses give a shallower depth of field than shorter focal lengths; but actually if you were to stand in one place and photograph the tree with a 300mm lens, and then move closer to it and photograph it with a 50mm lens, in such a way that the size of the tree in the resulting image was the same, then at any given aperture the depth of field given by each lens would be the same as well.

Normally when you look through the lens you will see everything as if your lens was set to its widest aperture, and changing the aperture will not change the image you see through the viewfinder, only the resulting image on film. However, if you have a camera with a depth-of-field preview button, you can see the effect of changing the aperture by holding the button down as you look through the viewfinder and change from one aperture to another. This is an extremely useful camera feature, especially for close-up work. If you do not have a depth-of-field preview button, it can be a useful learning experience to take a series of photographs with the camera on a tripod, changing the aperture for each frame, and keeping a written note of which aperture was used for each frame. Then you can look at the results and see the different effects you got from the various f-stops.

Differential focus

The technique of using a large aperture and throwing much of the photograph out of focus, with only a small part sharp, is known as differential focus, and is a wonderful technique in flower photography, especially when you want to go beyond a record photograph and create a more artistic interpretation of a flower. It can enable you to create an image with areas that become pure colour and shape rather than a record of what they actually are. These ideas will be discussed further in Section 3.

a large depth of field. Even in this situation you must be careful to focus correctly – you should focus on something between one third and one half of the way between the closest and most distant elements of your picture to give you the maximum possible depth of field. If you focus on the poppies at the front, you will waste some of your possible area of sharpness in front of the poppies, i.e. not in the photograph at all; and similarly if you focus on the very far mountains, your depth of field may not extend as far forward as the poppies immediately in front of you.

Some older lenses have a depth-of-field scale engraved on them (see diagram, below), and this takes much of the guesswork out of the equation. Instead of focusing by looking through the

viewfinder, set your camera on a tripod and focus using the scale. The different-coloured lines on the depth-of-field scale correspond to the different colours of the f-stop numbers on your lens.

Distance between camera and subject

Depth of field is affected not only by the choice of aperture, but also by the distance of the camera from the subject. With any given lens, the closer you are to your subject, the shallower your depth of field will be. For example, if you photograph a wide landscape with a standard lens set at f8, with your point of focus halfway into the vista, your depth of field will be much greater than it would be if you photographed a flower with the same lens, still at f8, at its closest focusing distance.

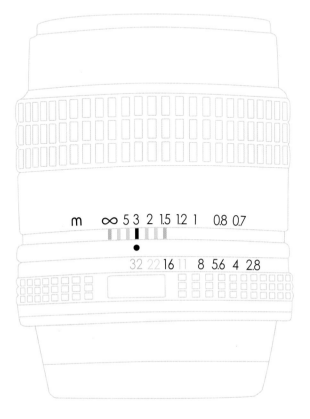

Depth-of-field scale

This illustration shows the depth-of-field scale on my micro-Nikkor 55mm lens. The orange lines on the depth-of-field scale relate to f32, the blue lines to f22, and so on. The four f-stops relating to the four largest apertures do not have coloured lines, as depth of field on these apertures is smaller and can't be shown on the scale.

In the illustration, you will see that the aperture has been set to f32. The infinity symbol (∞) on the lens has been lined up with one of the orange lines on the depth of field scale. The other orange line now points to 1.5m. This tells you that everything in your image between 1.5m from the film plane in the camera and infinity will be in focus. This scale is extremely useful when photographing large views, but not so good when photographing in close-up or when using wider apertures.

The principle of depth of field in a photograph and the way it can be controlled by choice of aperture is not difficult to understand, and yet it has a fundamental and crucial effect on the success or failure of your image. This is one of the main reasons why a flower photograph taken using the camera's automatic settings, rather than using aperture priority metering and controlling the settings, is unlikely to succeed.

The term 'depth of field' is used to describe the zone in a photograph which appears completely sharp. Imagine that you are looking through your camera's viewfinder, and you can see a field of poppies in the foreground, a line of trees in the middle distance, and a range of mountains in the background. Your eye sees everything as sharp, from the nearest poppy to the furthest mountain. The camera, however, depending on the lens that you are using and your choice of aperture, will not necessarily record everything in the photograph as sharp. The largest possible depth of field will render everything in the resulting image sharp. A small or narrow depth of field will only render part of the image sharp, depending where you focus – so the poppies may be sharp but the trees and mountains out of focus, or the trees may be sharp with the poppies and mountains out of focus, or the mountains may be sharp with both poppies and trees unsharp.

Clearly the first decision you have to make is how much of your image you actually want to be in sharp focus. If you are taking a fairly wide landscape view with different but equally important elements at different distances from your camera, you may decide that you want everything to be sharp. However, when you are working at close focus on a single flower, and the background to the flower is a rather unattractive tangle of stems and leaves, you may wish to have only the flower sharp and the background out of focus. Having made your decision, how do you achieve the effect you desire?

Choosing the correct aperture

This is where an understanding of the effect of changing your aperture comes in. A large aperture (which will be a low f-stop number such as f4) will give you a shallow depth of field, while a small aperture will give you a larger depth of field. So if you want to make your flower stand out from its background, focus carefully on the part of the flower you wish to be sharpest, and use a large aperture to throw the background out of focus. This is a technique which can turn a messy tangle of grass into a pleasing wash of shades of green, thus enhancing your flower instead of distracting from it. Alternatively, to go back to our original example, if you want the poppies, trees and mountains all to be sharp, you will use a very small aperture to give you

SELECTING YOUR APERTURE

Your choice of aperture may also be influenced by many different factors – for instance if you choose a very small aperture, this will necessitate a longer shutter speed, which may mean that you cannot hand-hold the camera, or that even with the camera on a tripod, there may be movement in the picture if the flowers and trees are blowing in the wind. Sometimes a compromise has to be made between the most desirable aperture and the most suitable shutter speed.

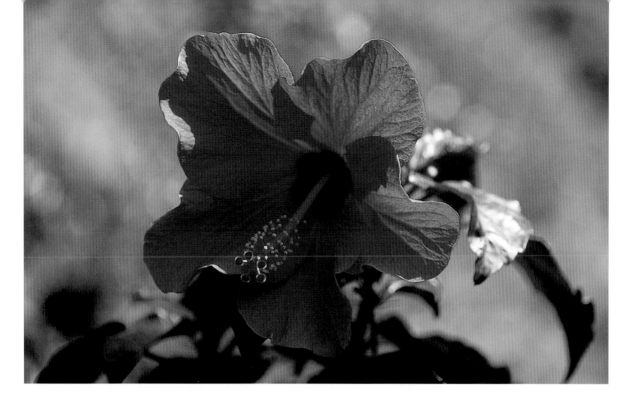

f8

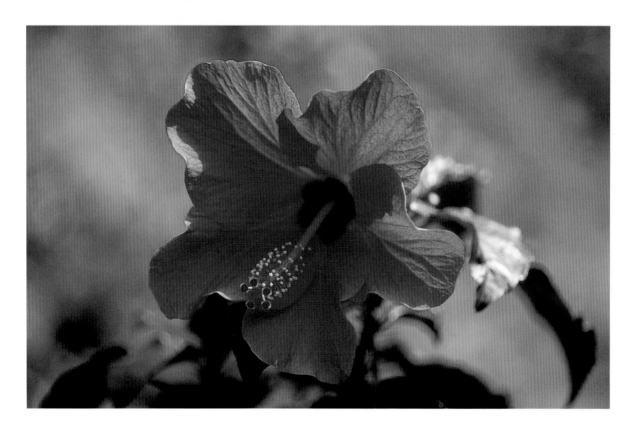

f4

POPPIES and LAVENDER (page 64)

In each of these photographs a very shallow depth of field (that is, a wide aperture) was selected so that the flower on which I focused would stand out from the flowers in front of it and behind it. This is an example of differential focus – the subject is separated from its background not by a difference of colour or shape, but merely by a shallow plane of focus.

Photographs of this type work better with a telephoto lens of 100mm or longer

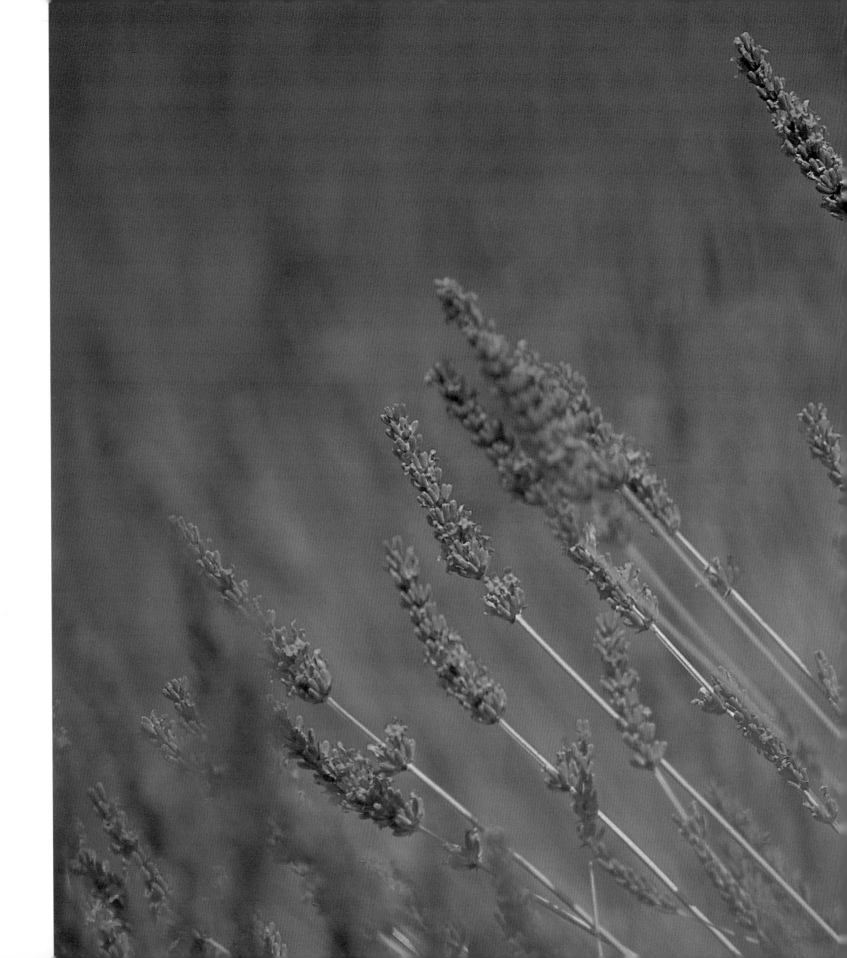

THE COLOUR CIRCLE

5

Understanding
Colour

As a painter has his box of paints, so the photographer

has the entire spectrum of nature's colours at his

disposal to create his images. Colour has a language of its

own, and it is important to understand some of it in

order to use it well. This section looks at the colour

circle and the effect of combining different colours with

each other, as well as examining warm and cool colours

and how they can be dominant or receding. It also

considers the special problems associated with

photographing blue flowers.

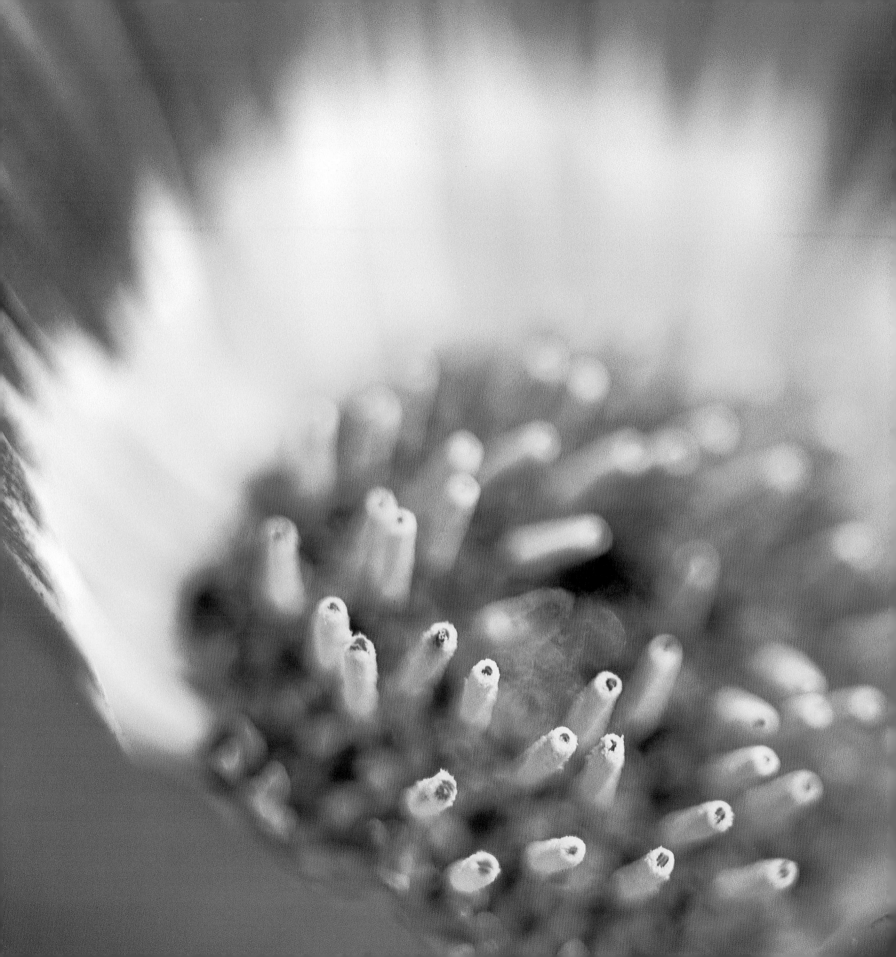

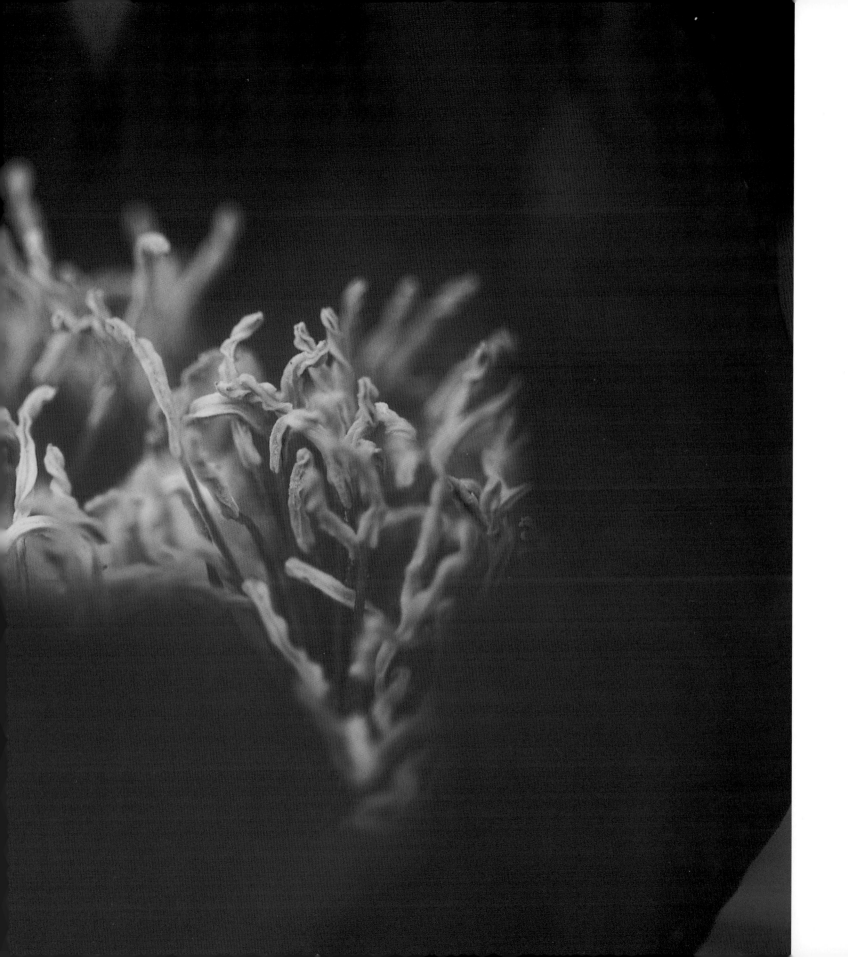

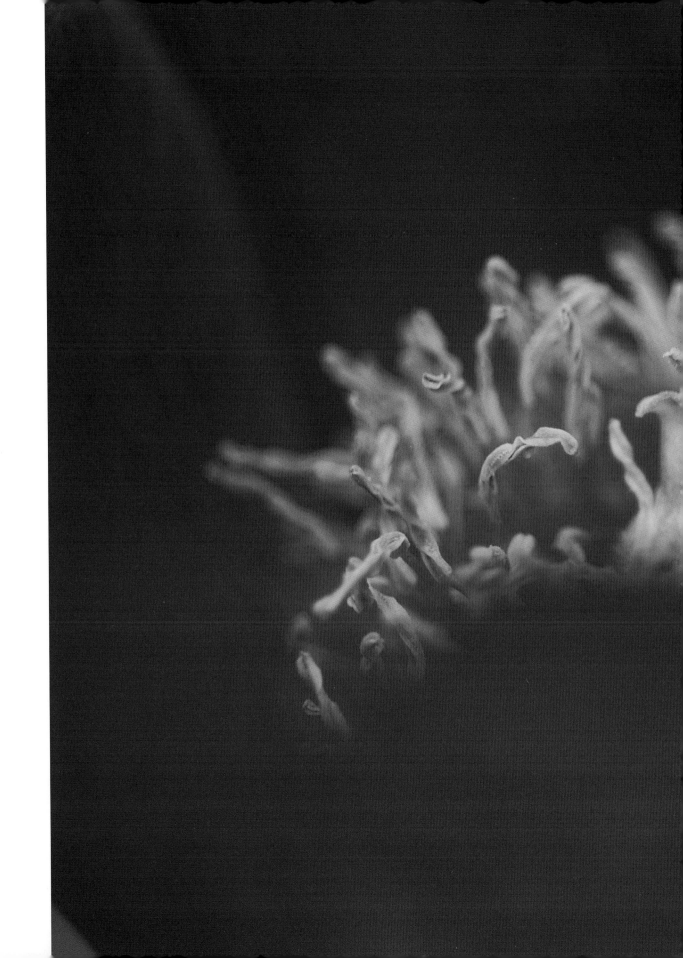

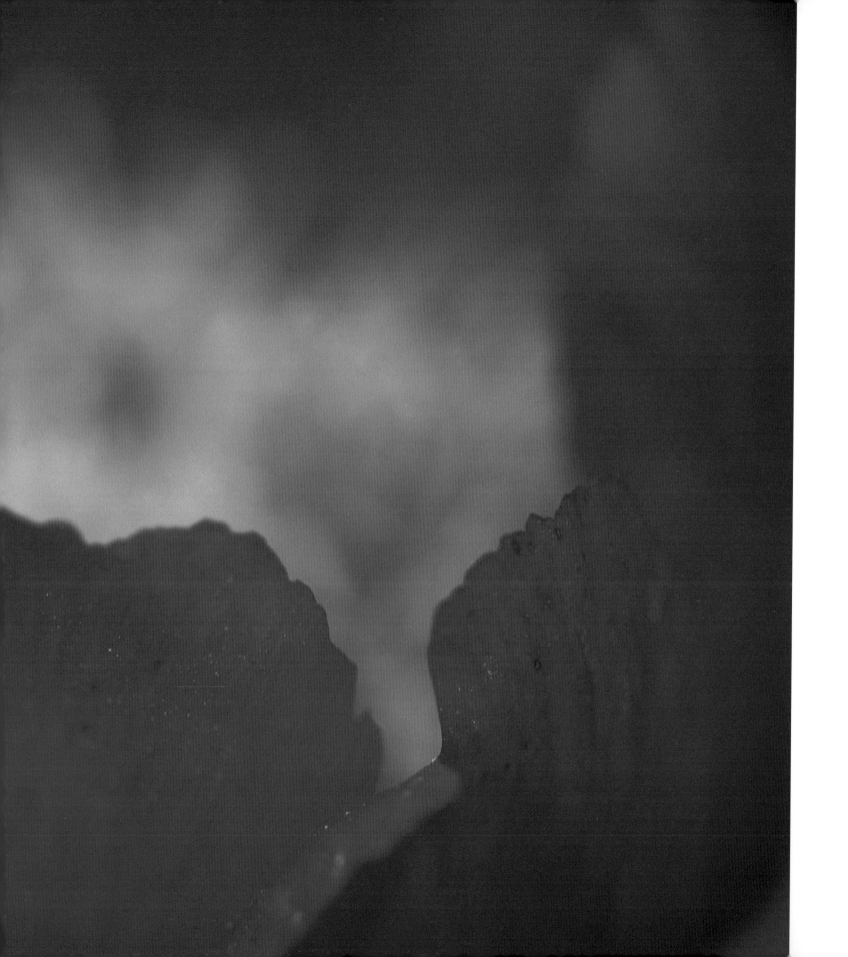

A macro lens used at its
closest focusing distance
gives a very shallow
depth of field. For the
following two images the
camera was on a tripod
and the only change that
was made between them
was a tiny movement of
the focusing ring: the
point of focus was on the
front petals for this image,
and on the centre of the
flower for the image on
the following pages. The
aperture was f4.

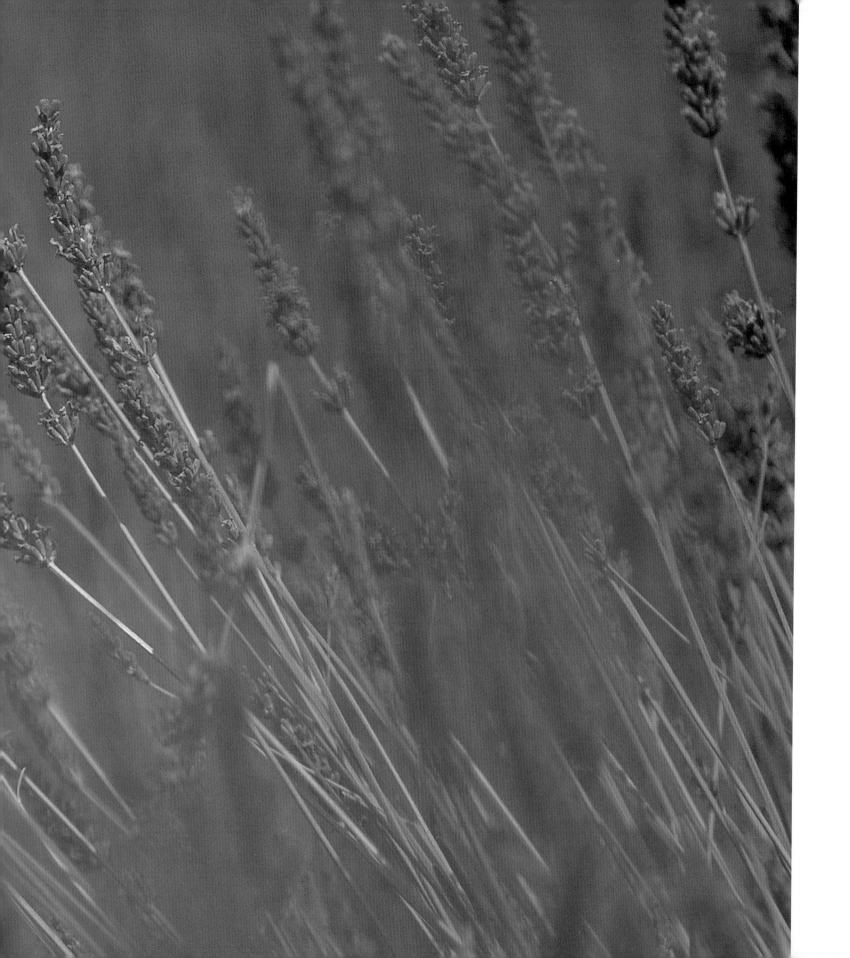

The spectrum of colours that we see is so often taken for granted, and yet the infinite variety of shade and hue is beyond our ability to catalogue or describe. Colours can be bright, vibrant, saturated, intense and brilliant; or soft, pastel, gentle, delicate and subtle; they can be warm or cool; they can contrast with each other, clash with each other, or harmonize together.

Colour moods

Colours affect us emotionally too – cool colours such as blues and greens are peaceful and restful, while warm colours such as reds and yellows are stimulating. The colours, hues and tints of the world are the photographer's palette.

TULIPS

Red is a warm colour and when very saturated, as here, it creates an especially vibrant image.

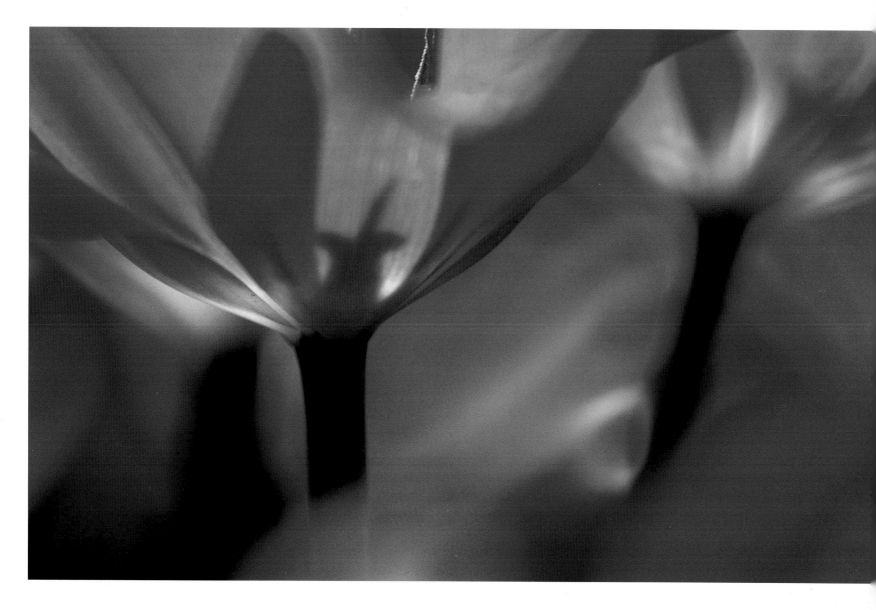

These colours are also in the warm spectrum, but are much more muted and pastel than those in the photograph of the red tulip.

Blues and greens are from the cool part of the colour spectrum, and combine together to make a restful image.

USING COLOUR

Much of the time you will combine colours together instinctively, but it is useful to have an understanding of basic colour theory in order to know how to achieve the effects you wish. Filling your frame with a random selection of as many colours as possible is not generally a recipe for success. As with many other aspects of photography, 'less is more' – simplicity of colour, as indeed simplicity of composition, often gives the most effective result.

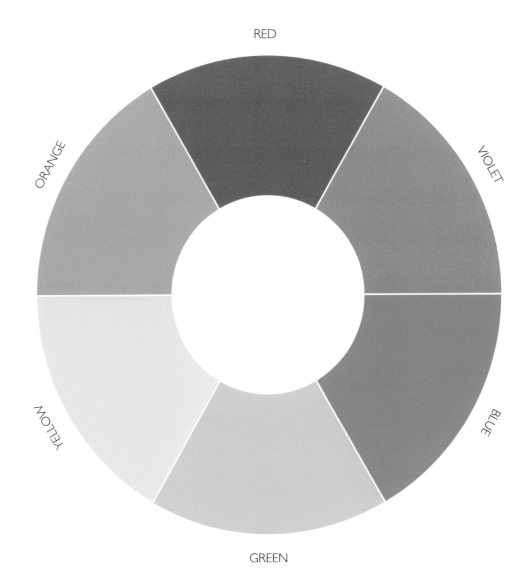

The study of the relationship between colours was begun by Leonardo da Vinci, and continued by many others, notably Michel Eugene Chevreul, who arranged colours into a colour circle. The basic principle of this is shown in the diagram above. The three primary colours, red, blue and yellow, are at three points on the circle, and between each pair of colours is the secondary colour produced by mixing the two primaries, i.e. orange, green and violet. Each colour on the circle is directly opposite its complementary colour – red is opposite green, yellow is opposite violet, and blue is opposite orange. Chevreul's circle includes many more hues of each colour, but the principle is the same. The colours adjacent to each other on the circle are harmonious with each other, whereas the colours opposite each other contrast, so that the juxtaposition of a primary colour and its complementary colour in a photograph will provide the maximum amount of contrast.

CORNFLOWER

This photograph, and the one of the poppy on the following page, illustrate the idea of using harmonious or contrasting colours in an image. The blue of the cornflower, below, harmonizes with the green of the grass; the whole image is restful, and neither element competes with the other for the viewer's attention.

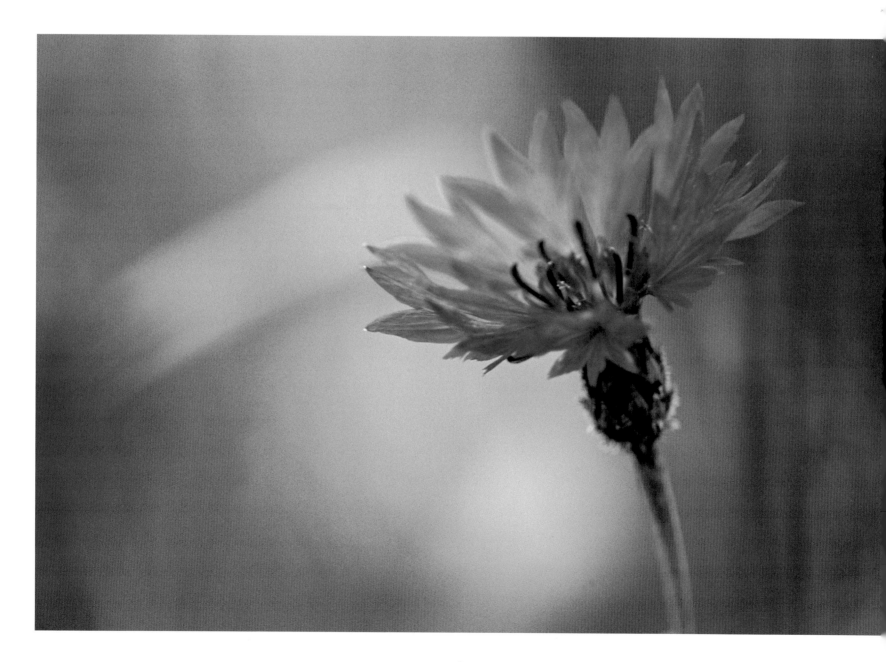

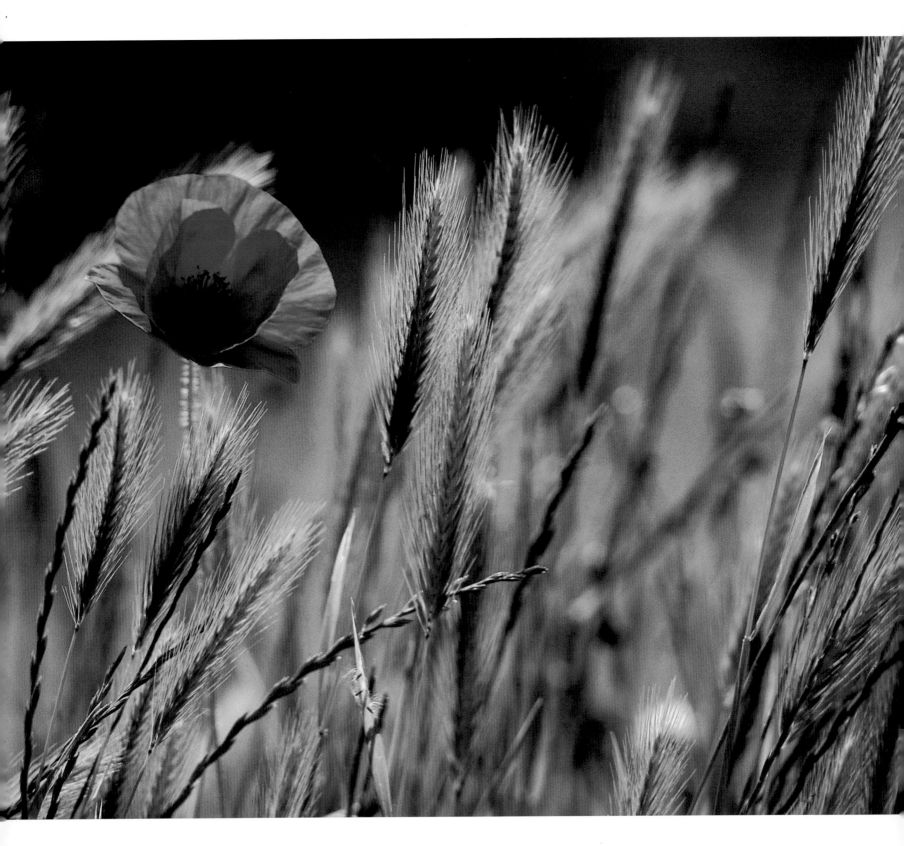

In this photograph, the red of the poppy and the green of the grass are contrasting colours, and the red seems to leap out of the background green. This also illustrates the idea of dominant and receding colours – warm colours tend to be dominant while cool colours recede. If you look at both this photograph and the previous one, the red of the poppy is the dominant colour; in other words, it is the colour which immediately draws your eye.

Colour awareness

It is always better to be aware when taking the photograph that the positioning or the amount of a certain colour is causing an imbalance, rather than to look at the resulting image and wonder why it is that it doesn't work.

A small amount of red is all that is needed to draw your attention in a photograph. For this reason you must be very careful about allowing dominant colours to appear in the background to your main subject, as they will pull the attention away from it. Background colours should generally be either harmonizing with the main subject, or else receding colours. Imagine an out-of-focus red or yellow flower behind the cornflower in the photo on page 77 – it would immediately pull the eye away from the blue of the cornflower, and throw out the balance of the whole image. On the other hand, out-of-focus cornflowers in the grass behind the poppy would not be a problem, as they would harmonize with the green of the grass, and recede in comparison with the dominant red colour.

Achieving the right balance between the colours in your image is largely an intuitive matter. Of course a photographer does not have as much freedom in this as a painter, as he is constrained by the colours that actually exist in the subject he is photographing, whereas a Post-Impressionist or modern painter can paint his subject in whatever hues he wishes. Nevertheless it is important to be aware of how the colours of the various elements that you are seeing through your viewfinder behave, so that you can adjust your angle or your composition or your background in order to make your image work.

Experience and intuition will tell you that a small amount of red will leap out from a green background, but that the reverse will not be true, because although the colour contrast is still there, the red is more dominant than the green. In the same way, an orange flower will be stunning against a blue backdrop, but a blue flower against orange

may not feel 'comfortable', because the subject is a receding colour and its so-called supporting element, the background, is a dominant colour.

You can fine-tune your sensitivity to and awareness of colour all the time, not just when you are out taking photographs. Look at colour schemes that people have used in their homes, and analyze whether or not they work well, and how the colours used in a room make you feel when you are in it. Look at how colour has been used in advertising to play on our emotions; for instance, many advertising photographs will have been taken with heavy warm-up filters because warm images are considered more appealing than cold ones. Look at the effect of different light on colours in natural and man-made objects all around you at various times of the day.

It can be especially valuable to study not only how other photographers have used colour, but also how painters have used it, especially in the last hundred years or so when artists pushed beyond the boundaries of 'real' colour. When you see a photograph or a painting that pleases you, try to analyze why it is that it works. Do you generally respond more to pictures using harmonious colours or contrasting, complementary colours? Do you prefer a preponderance of warm tones or cool tones? Would you choose a picture with pastel shades or with vibrant, saturated colours? Some of this may seem far-removed from actually being out in the field with your camera, but a better awareness of colour, even if it is almost subconscious, will always help create a more beautiful photograph.

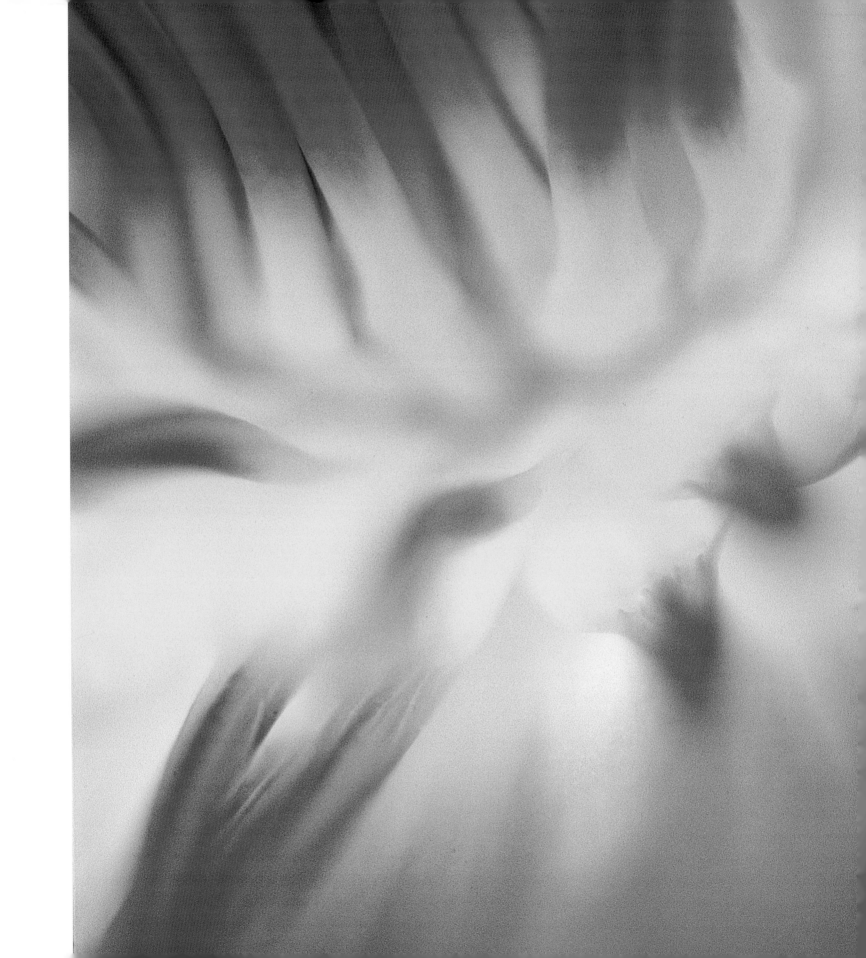

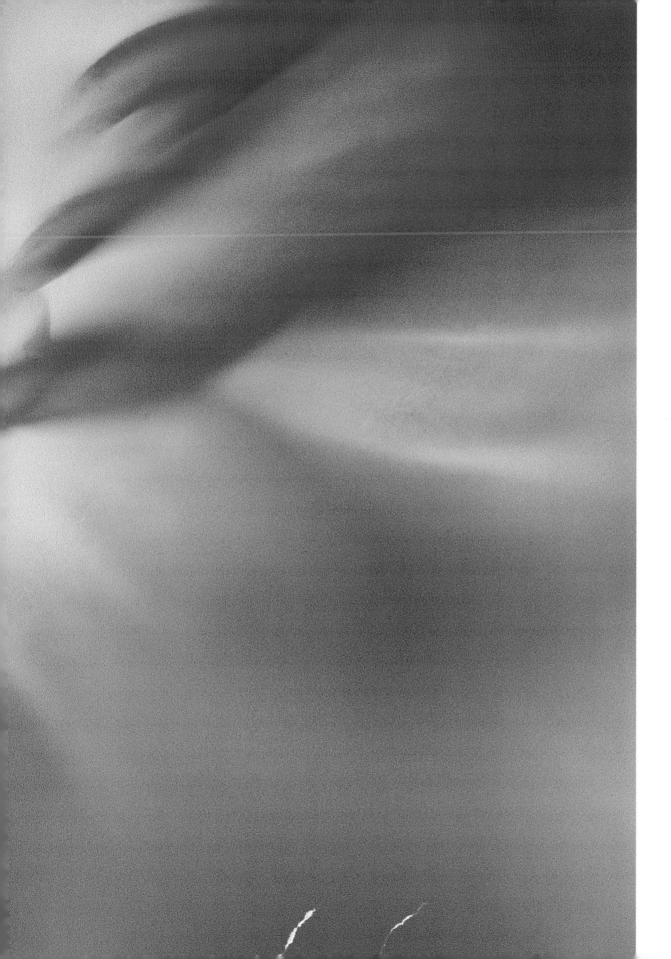

WATER LILY

Sometimes colour can itself become the subject of a photograph. This photograph is so abstract that it is about glowing colours and flowing lines, rather than simply being about a water lily.

I used a macro lens at f/4 with an extension tube so that depth of field would be absolutely minimal, adding to the impressionistic feel of the image

These poppies were growing on an allotment less than half a mile from my home. The allotment was enclosed by a car park, a leisure centre and the backs of a row of buildings – not at first sight an auspicious place to look for inspiration for a photograph! However I used a telephoto macro lens to block out the surroundings and concentrate entirely on the subject in hand.

CASE STUDY 2: Poppies on an allotment

I decided to concentrate first of all on the lovely wavy edges of the petals.

However, I also loved the way that different shades of red and pink grew entwined with each other in a vibrant harmony of colour, so I tried to find a composition that would include more than one shade. This wasn't easy, as the flowers were generally quite far apart from each other, and to include two blooms meant also including a large amount of tangled foliage in between.

My second photograph was an attempt to include both pink and red flowers. I used a very shallow depth of field to soften the stalks and leaves, which has created quite an abstract image, an effect that has been heightened by the wind movement visible in the pink poppy.

I still didn't feel completely satisfied, and so continued to look for different angles, moving around the poppies and looking at them from various heights until finally I found a way to juxtapose the red and the pink against each other.

FOCUSING IN

Looking through a telephoto macro lens is a marvellous way to block out your surroundings and focus entirely on your chosen subject.

The first thing that attracted me about these flowers was the lovely wavy edges of the petals, and so my first image concentrated on this.

Using colour

By including only part of each flower and concentrating on the area where they overlapped (page 85), the amount of green has been kept to a minimum, leaving just enough to complement the red and pink.

Location:
Surrey, England

Time of year:
August

Camera:
Nikon F100

Film:
Fuji Velvia

Lenses:
200mm macro

Filters:
81B warm-up

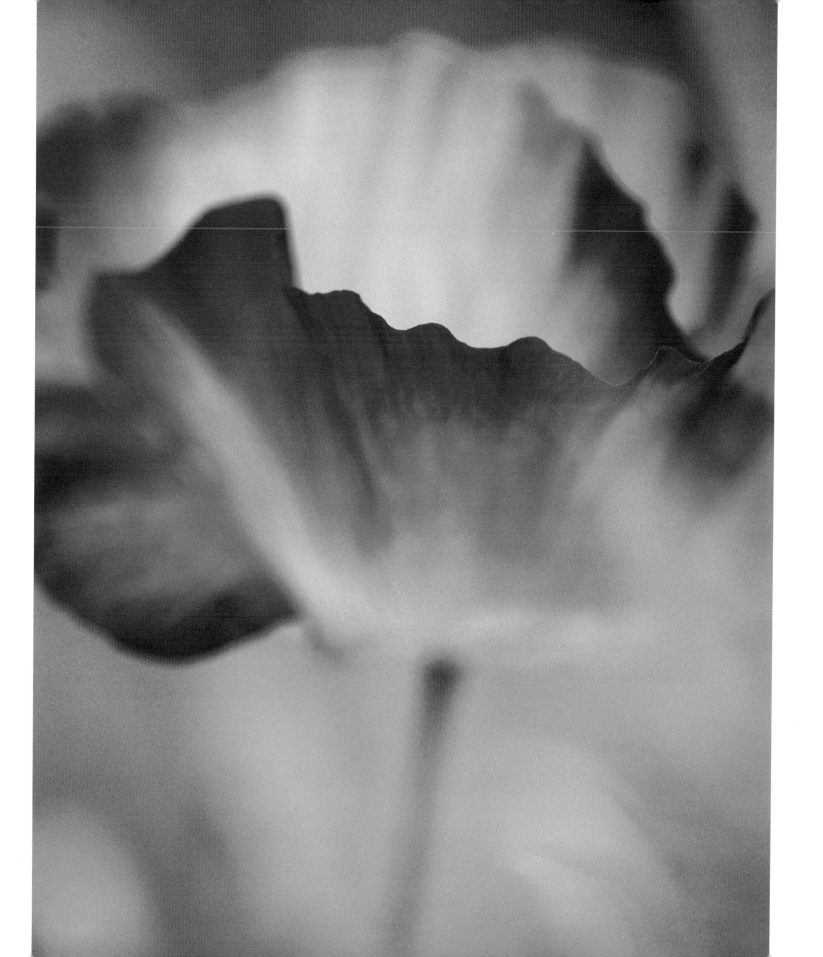

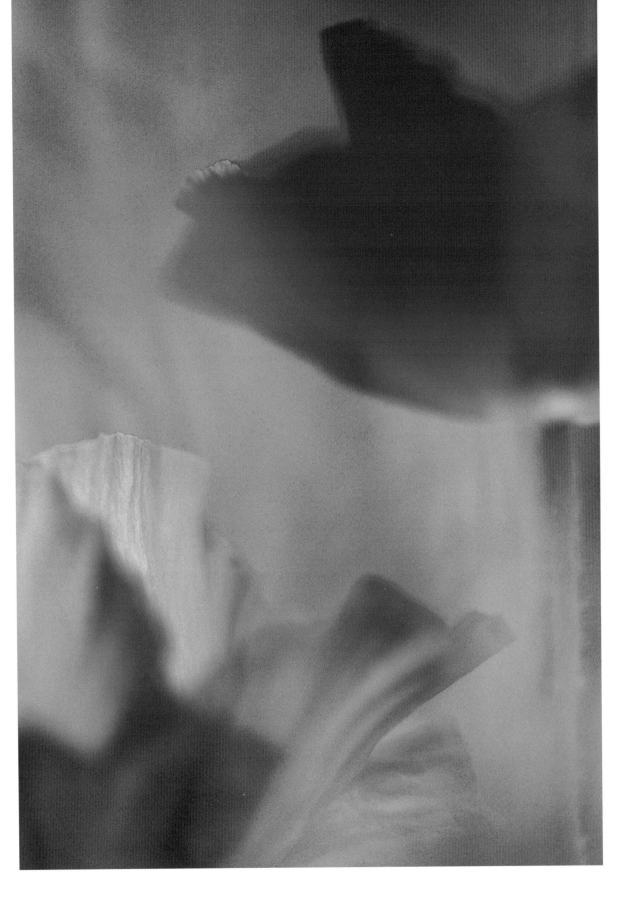

Next, I tried to find an image that would include both pink and red flowers.

This photograph was my favourite of the day, as it included both red and pink flowers, still highlighted the wavy petal edges, and had enough sharpness in it for the eye to find somewhere to fix on while still having plenty of lovely abstract colour.

6

BLUE FLOWERS

There is something very special about blue flowers, perhaps because they are usually so outnumbered by flowers in the red/pink/orange/yellow spectrum. It's interesting to note how many shades of blue are named after flowers – cornflower blue, gentian blue and hyacinth blue to name just a few. However there can be problems reproducing the blue of a flower on film, and there has been much discussion in books and photographic magazines about the best techniques for photographing them. The petals of many blue flowers reflect infrared wavelengths, which are invisible to the human eye, but to which the film emulsion is sensitive, with the result that they appear as pink rather than blue in the resulting image. This is a problem frequently encountered when photographing bluebells.

There are various ways to counteract this. One is to use a very pale blue colour correction filter, but of course this will add blue to everything in your image, not just the blue flowers, and so may not always be suitable. However, I have had some success using a graduated blue filter (which is usually used for adding blue to skies) upside down so that the blue part of the filter is over the bluebells, but not the rest of the image. Another way to keep the bluebells blue is to photograph them in the shade rather than in sunshine. I mentioned in Chapter 1 when discussing filters (page 20) that photographing in open shade on a sunny day would produce a blue cast in your photograph – well this is one situation when that can work to your advantage!

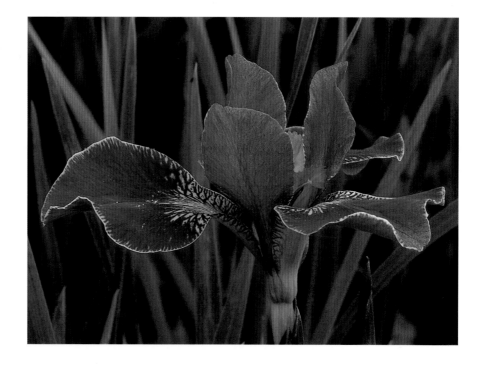

BLUE IRIS (above) and BLUE HYACINTH (below)

Not all blue flowers will record as pink – these photographs were taken without any colour correction filters, and are showing no tendency towards magenta or pink.

BLUEBELLS

The first of these photographs (right) was taken when the sun was shining, and the second (below) when it was obscured by a cloud. You can see how much bluer the bluebells appear in the overcast light.

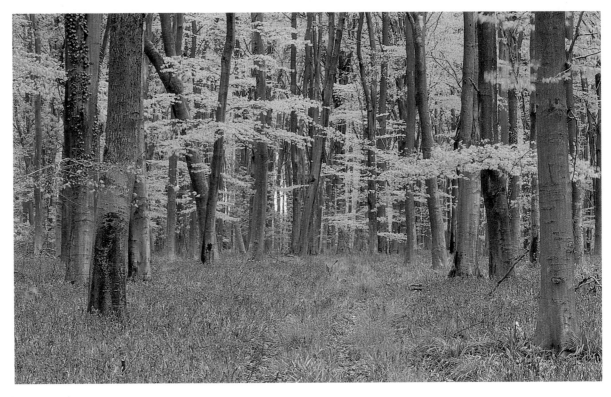

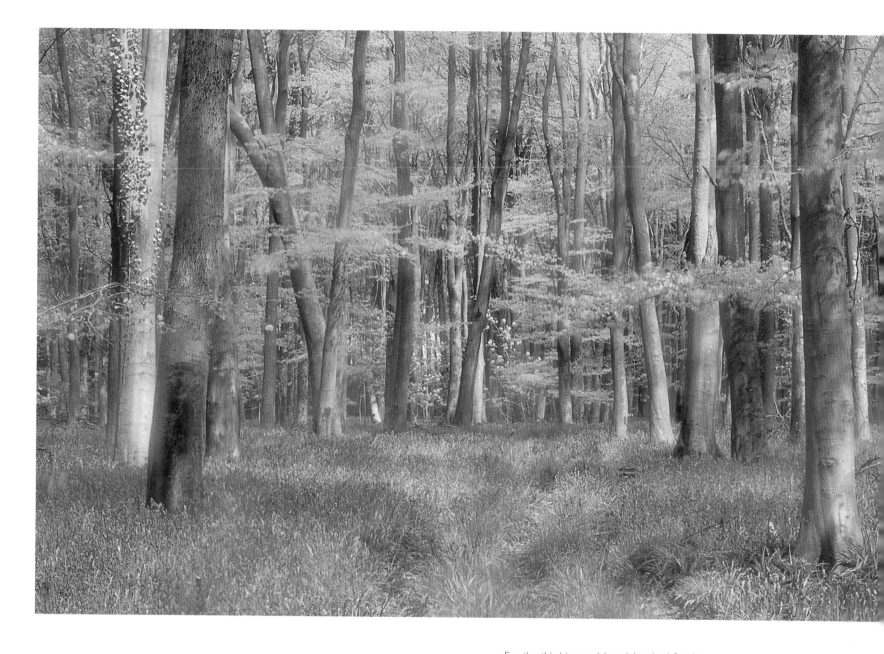

For the third image (above) I waited for the sun to appear again, and added a blue graduated filter with the blue part only over the bluebells. I also used a soft-focus filter to lessen the contrast caused by the sun on the flowers. The result is that the bluebells are an acceptable blue, and the beneficial effect of the sunlight on the leaves and trunks of the trees is now an added bonus.

COOL LIGHT

The light is cooler and therefore bluer at midday than it is early or late in the day, and this will also help your bluebells to stay blue.

On a recent visit to my local florist I was thrilled to find a rather unusual blue water lily. I immediately bought it and rushed home with my purchase, put it in water, and set up my camera and tripod. I suspected that the blue that looked so beautiful to my eye might come out as magenta, but I didn't want to add a blue filter, as this would have detracted from the glowing warm yellow of the flower's centre. It was a sunny day, so I took it out into the garden and photographed it in open shade, and in the middle of the day. However, despite these precautions the resulting images were a very definite pink, much pinker than any other blue flower I had ever photographed.

Although I was initially disappointed, I decided to look at the photograph as an image in its own right, and without any preconceptions based on my knowledge of what the original subject had looked like. In fact, pink and yellow are a beautiful colour combination, and I decided that the image was an aesthetically pleasing one even if far from accurate!

Art versus accuracy

If botanical accuracy is important to you, then a photograph such as the water lily image would be of no use; but if you are photographing flowers in order to produce an artistic image, then fidelity to colour is not always vital to your success.

WATER LILY

Pink bluebells do not work because everyone knows that they should be blue; but in the case of this water lily, the person looking at the image would have no way of knowing that it was actually blue rather than pink so the photograph is a success in itself.

A macro lens plus extension tube allowed me to capture a life size image on film

From Document
to **Art**

Once you have mastered the techniques of

photography, you can make a competent record

photograph or document of a flower. This section looks

at how to move beyond this stage and interpret your

subject in a way that produces a more artistically

satisfying image. It considers various compositional ideas

and how to find the best arrangement of colour and

shape, as well as the use of soft focus and the choice of

background, plus special effects such as movement and

multiple exposures. The aim is to use your techniques to

express your emotional response to a flower in the

image that you create of it.

7

COMPOSITION

t is important that you become completely familiar with your camera and lenses, and practise the technical aspects of your photography so that they become second nature to you and you no longer have to concentrate on them. Then you can become free to create your image, using your camera and lenses as an extension of your mind and your eyes. To create a composition that really works you need to become completely absorbed in your subject matter, and you can't do this if you're anxious about whether you are doing the right thing with your equipment.

So, you are familiar and comfortable with your equipment and you have a full free morning ahead of you for your photography. You have arrived at a wonderful meadow full of wildflowers. Where do you start? I always think it is a good idea to take a little time to settle in to your location before you even take your camera out of the bag. Unless there are some terrific lighting conditions that you can see are not going to last, make a conscious decision to devote a while to walking around, just looking. Evaluate the quality of the light. Decide what it is about the scene that most attracts you.

Concentration

When composing your image you need to try to clear your mind of clutter – if you are trying to photograph with one eye on your watch, worrying about the next thing you have to do, you will not be able to give your composition the full attention it needs to really go beyond the obvious and become a striking image.

If you decide you want to take a general view with the flowers in their surroundings, consider carefully which elements you want to include and which you will leave out. Be careful not to clutter your image with too much information. A single tree surrounded by flowers may prove to be a more powerful composition than several trees, a fence, a house and some flowers. Once you have made these decisions, it's time to take out your camera and tripod and make the image that you have already pre-visualized.

I find that I do not pre-visualize so much when I am working close up as I do for broader scenes. Here I adopt a different approach. First, it's important to select an unblemished flower. This may sound self-evident, but there have been many occasions when I have been so absorbed in the overall composition that I've failed to notice a brown spot or a ragged petal edge. Although often tiny, such imperfections can then look glaringly obvious in the resulting photograph. Once I've found a suitable flower, my favourite way of working is to set my macro lens at its closest focusing distance and its widest aperture, and then move around the flower, looking through the viewfinder all the time, moving slowly in and out, to left or right. A movement of only millimetres will make an enormous difference to the resulting composition. The plane of sharp focus will be very narrow at this close distance – watch how the whole image changes as you move towards or away from the petals, throwing different parts of the flower in and out of focus. Work at different levels – from above the flower, at its own height, below the petals. There are absolutely no rules here, and all you have to do is find a composition of colour and shape that works for you.

FRAMING

It can sometimes be helpful to take with you a plastic 35mm slide mount which you can use as a viewing aid – by holding it up to your eye and looking through it, moving it further away or closer to you, you can 'frame' possible subjects and consider the various compositional possibilities.

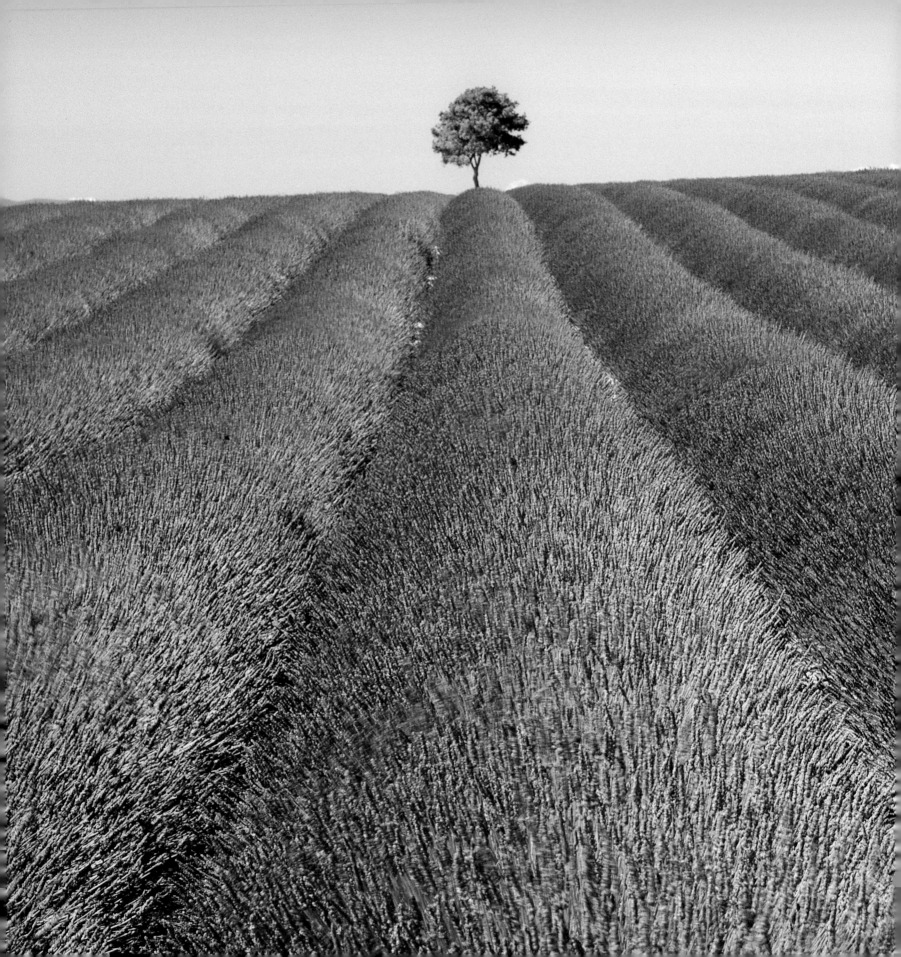

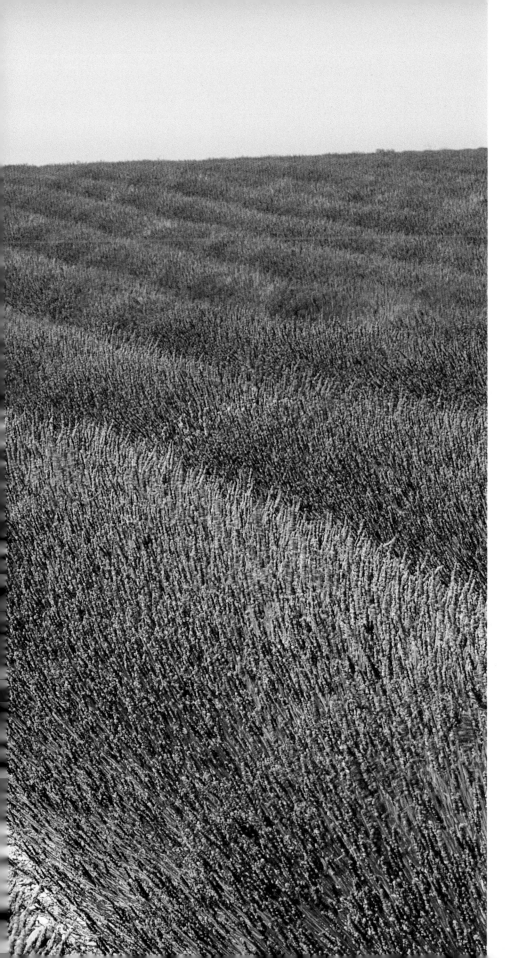

LAVENDER FIELD, PROVENCE

A simple composition is often the most effective. This picture has only three elements: lavender, sky and tree. The lines of lavender lead the eye in to the single tree on the horizon, which, although only a small part of the image, plays an important part in the overall composition – cover it up with your thumb to see how the picture falls apart without it.

The use of a telephoto lens has helped to compress the rows of lavendar and emphasize the pattern that they create

Getting in close

Don't be afraid to go so close that the parts of the flower nearest to you become out of focus. The magic of this experience is that you begin to view your subject in a way that you never normally do. The flower may even cease to seem like a flower, and become instead a configuration of colours and tones, shapes and forms.

WATER LILY

At the closest focusing distance of your lens, the smallest movement can make a very noticeable difference to your composition. As I looked at this water lily through my camera, moving from right to left, closer in or further away, the balance of the composition continually changed. The difference in camera position for these two photographs was only a matter of millimetres, but you can see the effect of the movement clearly in the resulting images. I think the second is the more successful one, because the focus on the inner petal tips gives more of a point for the eye to rest on as a centre of interest.

I used a macro lens at f/4 with an extension tube to give a very shallow depth of field, so that much of the image would consist of vibrant washes of colour

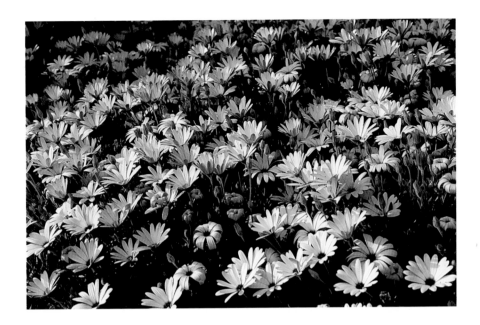

OSTEOSPERMUMS

This bed of osteospermums presented some problems, because the sunlight was harsh and caused some of the flowers to cast hard shadows onto others. Also, not every flower was in perfect condition, so a general photograph of the flowers en masse was not really viable. Because of this I decided to go in close, and after moving around them with my macro lens set at its closest focusing distance, I found that the best angle was from flat on the ground, almost underneath the flowers. Since they were only a few inches high this precluded the use of a tripod, and I just rested the camera on the ground. This viewpoint solved the problem of the hard light, as the light was now being partially filtered through the petals of the flowers, but with enough direction still to give some pleasing rimlighting on the side of the stalk.

I added one stop of exposure above the camera's suggested reading here, because the flowers were light in colour and also partially backlit

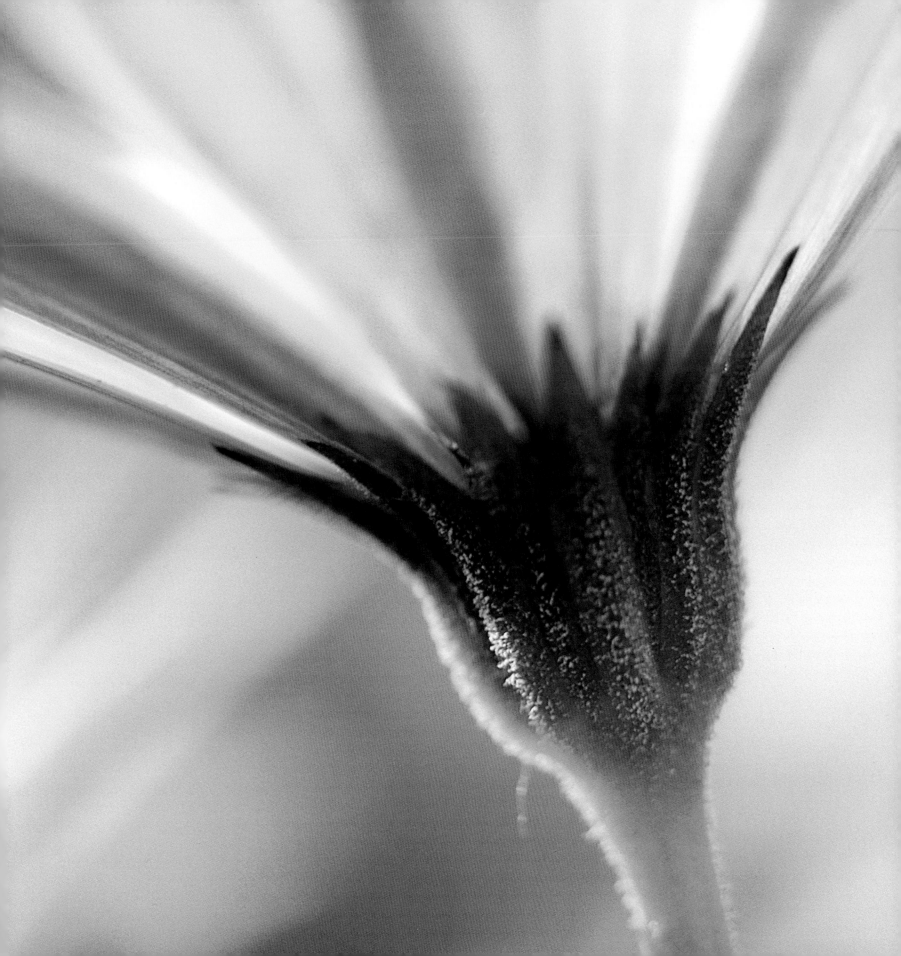

Extracting detail from the whole

Of course there will be other situations where you will want neither the large, general view nor the extreme close-up, but something in between the two. I remember once driving with great anticipation to a garden that advertised 'drifts of tulips reminiscent of Holland'. On arrival I was disappointed to find only a few rows of tulips, generally planted several inches apart from each other, so that it was impossible to fill the frame with clustered tulip heads as I had hoped. I walked around for a while until I found a few yellow tulips planted closer together so that their heads were actually touching. The background to the flowers was not good – bare earth and pathways – so I knew I needed to go in close.

What I was doing in this situation was abstracting the elements that I wanted from their surroundings. This, like appreciation of colour, is something that can be practised even when you are not taking photographs. When you look at any scene, imagine how you might make a picture out of it by abstracting some of its elements, not necessarily complete elements but just parts. If you wanted to make a record photograph of a flower, you would photograph the complete flower, using a small aperture to record everything in sharp focus. If you want to go beyond a record and make an image that you find aesthetically pleasing and emotionally satisfying, then anything and everything becomes possible. In focus, out of focus, a whole or a part, identifiable or not, the choice is yours.

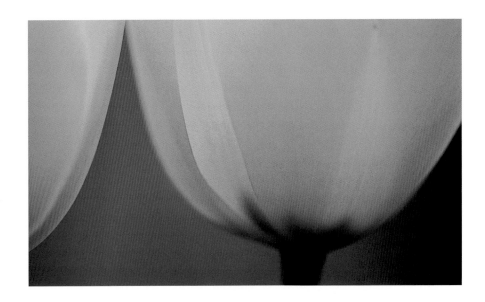

TULIPS

My first composition (above) is of two yellow tulip heads, but only part of them – to have included the whole blooms would have meant also including detracting elements from their background.

The use of a 200mm telephoto lens enabled me to isolate parts of the flowers from their surroundings

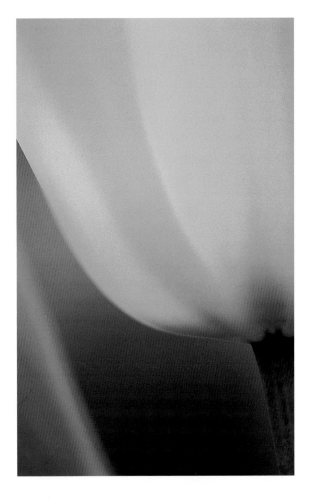

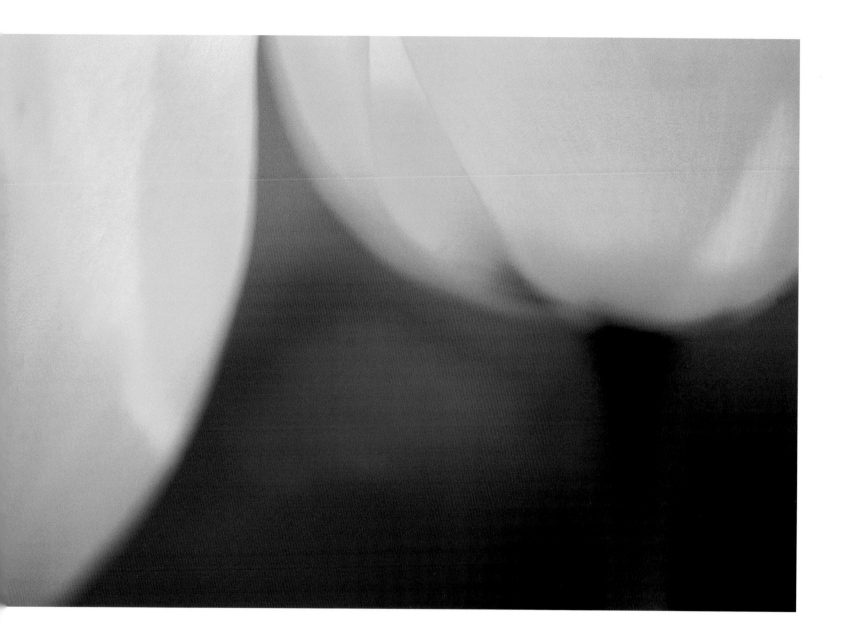

I then moved my position only slightly and discovered that I
could now see a pink tulip behind the yellow ones. I threw
this completely out of focus so that it became a wash of
pink, and ended up with the two images left and above, my
favourites from the day.

There are some compositional 'rules' which you may hear mentioned. Perhaps the best known of these is the rule of thirds, or the 'golden rule'. It is indeed true that a composition may often be more successful with its subject positioned according to this rule. However, like all rules this one is made to be broken on occasion! If every image you make uses the rule of thirds, it will start to seem repetitive and lose its effectiveness. By all means consider placing your subject on one of the intersections, but if you find you like it better somewhere else, then put it where it feels right to you.

One note of caution – you may not always find a picture that works in any given situation. After moving all around your subject and trying every angle, you may not feel you have found anything. Don't be disheartened! This is bound to happen sometimes, because after all you have to work within the constraints of your subject matter, and it may be that the shape of the petals, the colours behind your chosen flower, the direction of the light, or any one of many other factors is such that you can't get the composition you want.

Realizing that you can't make an effective image out of a particular subject is in itself part of the learning curve. But when you do move into a flower with your lens and find something beautiful, something that almost transcends the reality of the plant itself, it is a truly wonderful experience!

Rule of thirds

According to the rule of thirds, the picture space is divided into nine rectangles by drawing two vertical lines and two horizontal lines as shown here, and for maximum impact the centre of interest in a picture should be placed on one of the intersections of these lines.

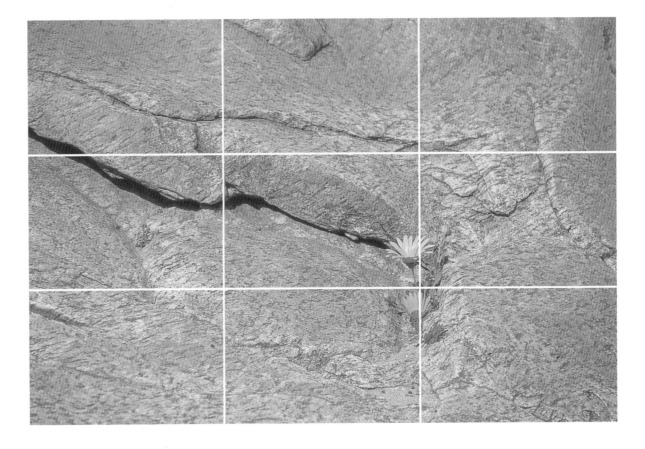

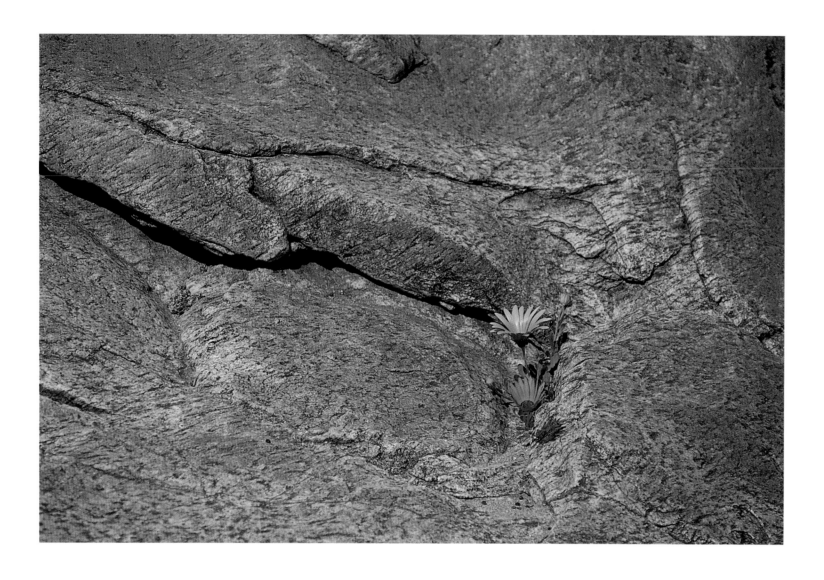

NAMAQUALAND DAISY AND ROCK

In this photograph the flower was deliberately made small in the frame to emphasize the contrast between the flower and the barren rock around it; placing the flower according to the rule of thirds made a stronger composition in this instance than putting it in the middle of the frame.

I used an 81B warm-up filter to enhance the warm colours of the rock and the flower

Composition

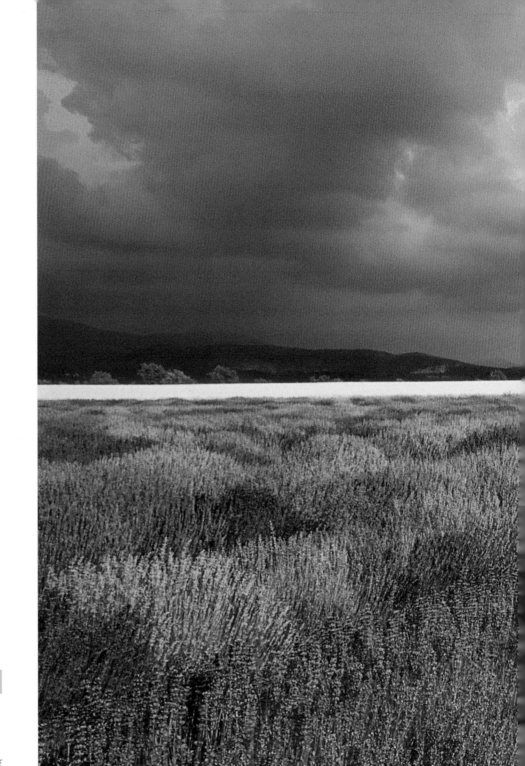

LAVENDER FIELD, PROVENCE

This is another image in which the rule of thirds has been used. Although the tree is not the main subject of the image, it is a focal point because of the way the lines of lavender lead up to it, and placing it according to the rule of thirds has emphasized this.

I used a wide-angle lens to emphasize the way in which the lines of lavender led to the tree. A graduated grey filter increased the drama of the dark sky. This light only lasted for a couple of minutes so I had to work very fast!

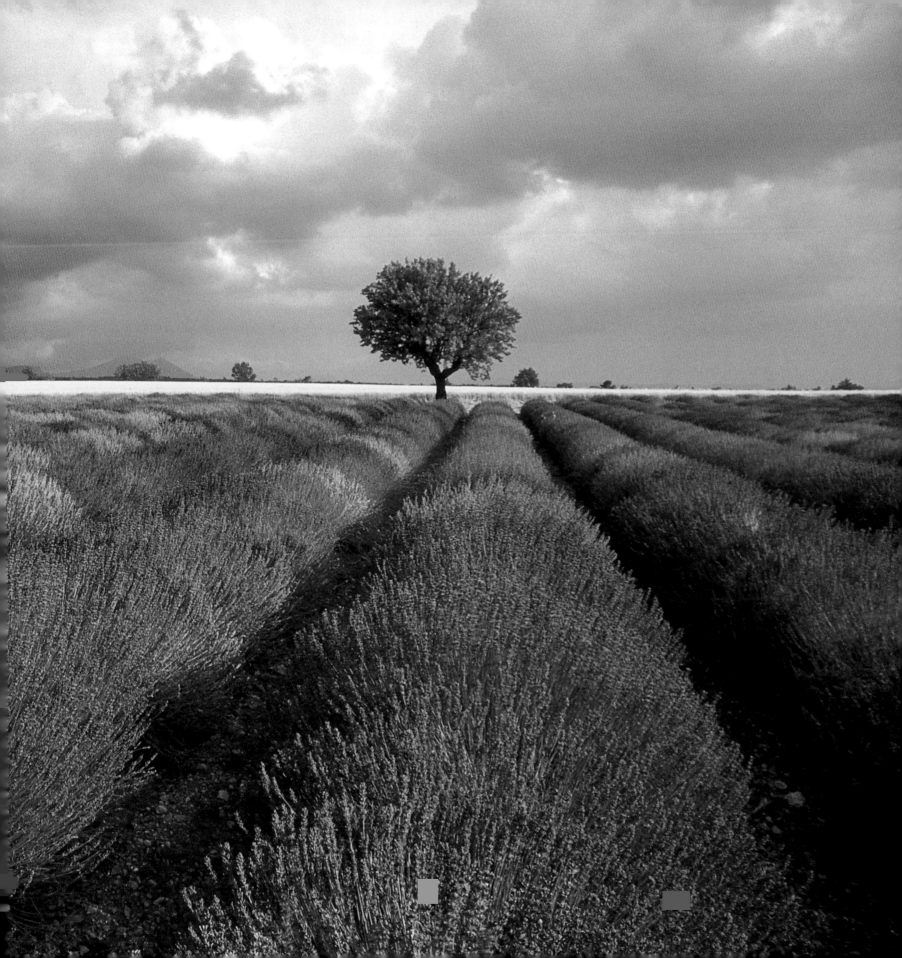

On a visit to the florist I bought some attractively coloured tulips, which I put in a vase and photographed one afternoon. I enjoyed the session but didn't feel I had made an image that I was especially pleased with. I left the vase of flowers on the window sill and just enjoyed the tulips as they opened wider and wider. Finally the petals started to fall off, and I noticed that they had curled slightly after falling but had retained their colours.

CASE STUDY 3: Tulip petals

I arranged some petals into various compositions and had an absorbing time photographing them, with a macro lens and extension tube to give me a life-size image. I became completely involved in shape, form and colour, making decisions about where a curve should start from and lead to, and which part of the image should be sharp and which not. The florist looked at me strangely on my next visit when I asked if she had any tulips past their sell by date that I could take home!

Location:
Conservatory interior

Time of year:
May

Camera:
Nikon F100

Film:
Fuji Velvia

Lenses:
55mm macro lens
with extension tube

Filters:
81B warm-up

As I looked at the tulip petals through my macro lens, I became absorbed in a world of curves, spirals and colours

Case study 3: Tulip petals

BACKGROUNDS

Except in cases where you are filling the entire frame with your flower, you will have to consider the background to your subject matter. The background should support and enhance your subject, not distract from it or compete with it, in just the same way as an orchestra should support a solo violinist, not compete with him by playing a different tune. However beautifully a flower is photographed, if the background is wrong, the final image will not work.

The amount of background which is included in your image will depend partly on the size of your subject and your distance from it, but also to a large extent on your choice of lens. As explained in Chapter 1 (page 16), a wide-angle lens will give you a much wider view than a telephoto lens. This can be used to advantage, especially when you want to photograph a particular flower within its environment – for instance, a photograph of an alpine flower could include snow-capped mountains behind the flower, and with a small aperture, both flower and mountains could be in sharp focus. However, if the area around the flower that you have chosen is not of particular interest, then you would probably choose to use a macro or telephoto lens

CHOOSING THE RIGHT LENS

The longer the focal length of the lens, the less background it will include, so if the background is cluttered or unattractive, it will be better to stand further away from your flower and use a long telephoto lens, than to stand close to it and use a standard lens.

instead, to concentrate attention on the flower rather than its surroundings. Unless there is something behind the flower which I feel adds to the impact of the photograph, I generally try to throw the background out of focus as much as possible. This is done by choosing a wide aperture – see Chapter 4 for a more detailed explanation of this.

Once you have focused on your chosen flower or petal, look very carefully at the rest of the image in your viewfinder. Any bright highlights thrown out of focus in the foreground or background will be very distracting in the final picture, as light or bright parts of the image always pull the eye, even if they are not sharp. Beware of white or yellow flowers behind or in front of your chosen subject, or even shiny leaves or drops of water reflecting light from the sky.

I often like to have some suggested shapes of petals or other flowers, so long as they are harmonious in colour and less bright than the main subject, rather than a completely plain 'poster' background. It's also a good idea to check for any leaves or blades of grass that may be in the same plane of focus as your chosen subject, and therefore sharp, and remove them if possible – this can often be done just by bending them out of the way and tucking them behind another stem. It's quite fun to experiment by taking two photographs of your flower, one with your smallest aperture and one with your widest, and then compare the results. It can be surprising to see how a tangle of leaves, grass and other flowers behind your chosen subject can be transformed, by changing your aperture, into a painterly wash of colour. The photographs of yellow poppies and bluebells on page 114 are an example of this.

Using the background

With the right mix of out-of-focus gentle colours, the background can become a very pleasing part of the image, without distracting from the flower which is the main subject. The background doesn't have to be just a negative space.

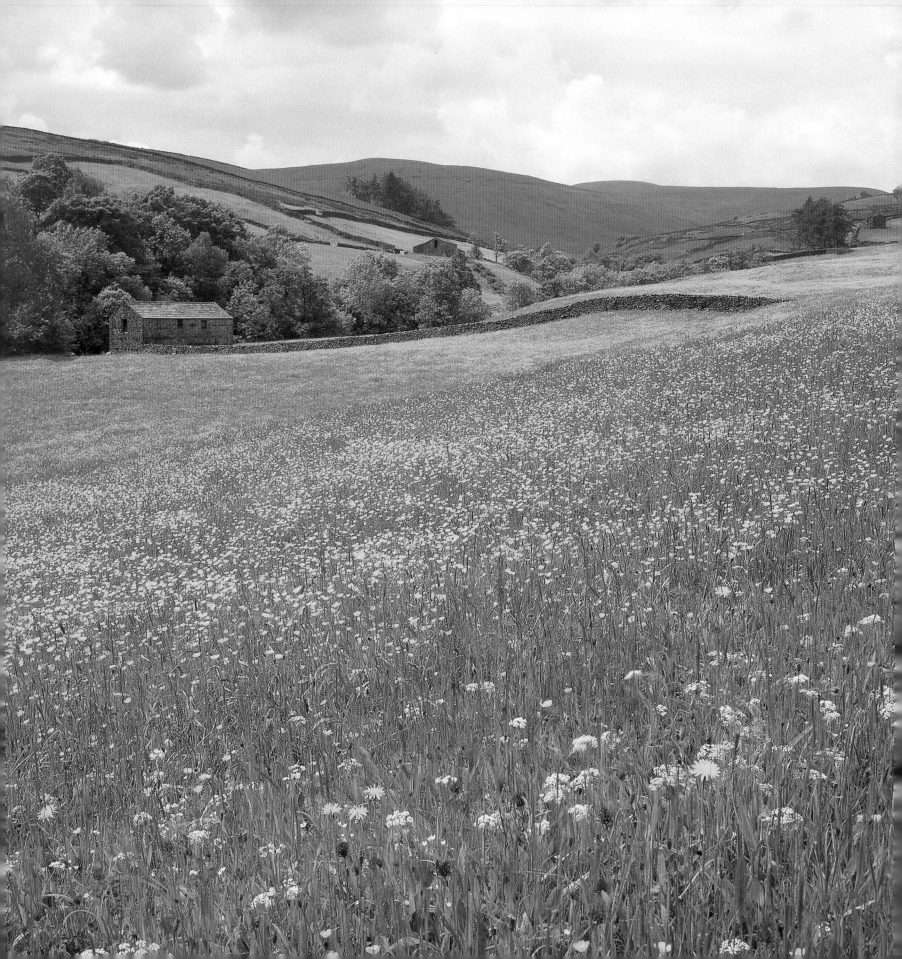

(left) WILDFLOWERS, SWALEDALE, ENGLAND

For a short time each June you can find fields in the Yorkshire Dales, England, carpeted with wildflowers. The use of a standard lens for this image has shown the flowers within their environment. A photograph of only the flowers could have been taken anywhere; this image, which includes the barn and the drystone walls, could only have been taken in Swaledale.

(below) DAISY

I was so engrossed with the daisy that was my subject when taking the photograph below that I failed to notice the out-of-focus daisies behind it. Being a soft colour they would not have mattered if they had been further away from the main daisy, but because they are almost touching it in the image, they detract from the success of the photograph.

f8

POPPIES AND BLUEBELLS

The first of these photographs (above left) was taken at an aperture of f8, focusing on the yellow poppies. This has meant that the bluebells behind the poppies have become a lovely wash of colour, enhancing the yellow of the main subject. In the second photograph (below left) the aperture was set to f32, which means that the bluebells have come partly into focus. Instead of being a wash of colour, they are a messy jumble of shapes, and distract from the main subject instead of enhancing it.

f32

Photographing Flowers

WILDFLOWERS, NAMAQUALAND

By using a very shallow depth of field, I photographed these flowers against a background of other similar flowers thrown so far out of focus that they provided a very harmonious backdrop of the same colour as the main subject.

Using my 200mm macro lens enabled me to exclude any distracting colours from the background

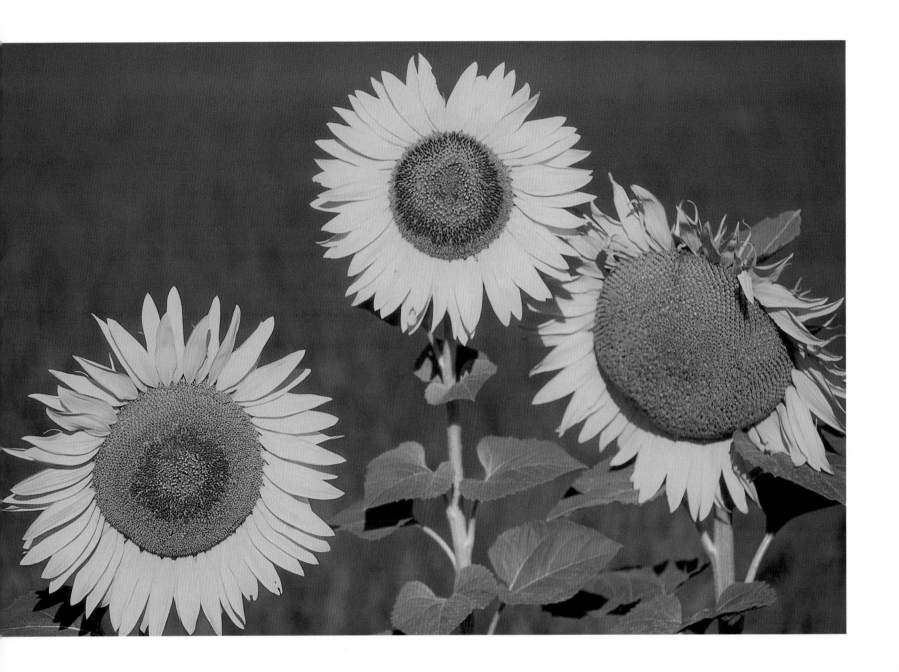

SUNFLOWERS AND LAVENDER

I was delighted when I found these three sunflowers
growing in front of a field of lavender, as purple and
yellow are complementary colours, and therefore the
lavender provided a wonderful contrasting background
for the sunflowers.

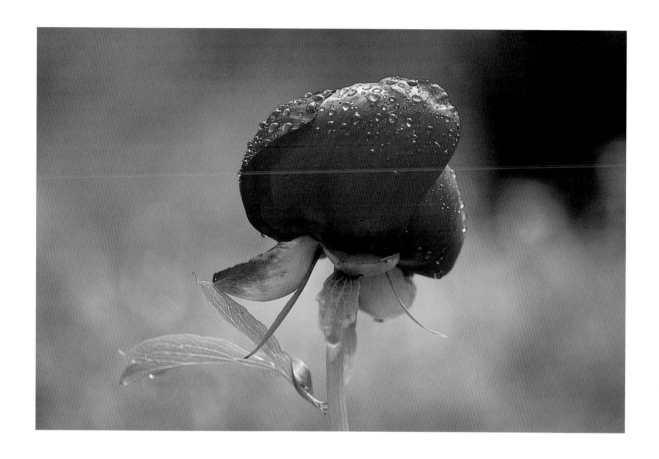

In the first of these photographs the background behind the peony is distracting, even with a shallow depth of field, with out-of-focus flowers and foliage distracting the eye from the main subject. By moving only two steps to my left, I was able to isolate the peony against a background of grass, which at f8 became a pleasing wash of green, enhancing the deep red of the flower.

A 200mm lens enabled me to isolate the flower against its background

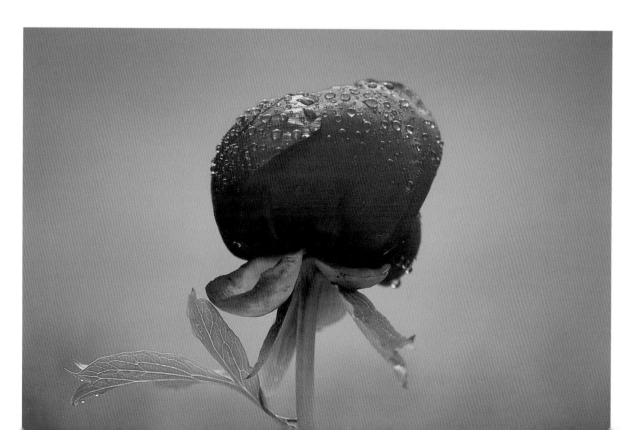

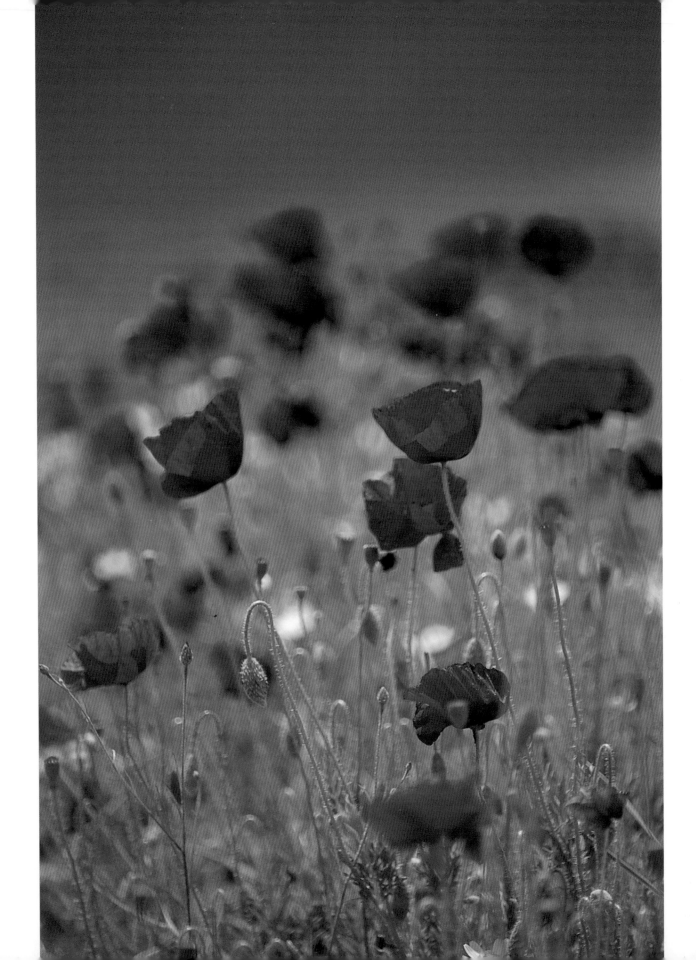

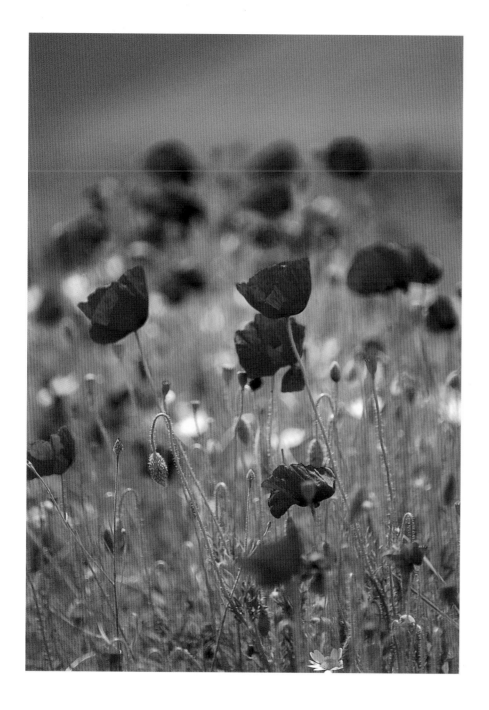

Sometimes you need to be aware of light falling on the background to your subject. In the first of these photographs (far left), a cloud had cast a shadow over the distant hills, while the foreground flowers were brightly lit, with the result that the background was a lovely dark blue-green, setting off the brightness of the poppies. Only seconds later, the cloud had moved so that part of the background was in sunlight again and became a light green, lessening the overall impact of the image (left).

A constant breeze meant that I had to use a shutter speed of 1/125sec to freeze movement in the flowers

Studio backgrounds

If you are photographing a growing flower, then you need to make the best use of the plant's natural surroundings, but when photographing a cut flower at home, you have complete control over the background for your photograph. Your choice of background colour will make an enormous difference to the 'feel' of the resulting image. Will you use a contrasting colour or a harmonious colour? A contrasting background, maybe in the flower's complementary colour, will make the flower stand out vividly, almost leaping out of the photograph, whereas a background in a hue similar to the flower will create a more harmonious result.

ORANGE GERBERAS

I photographed these orange gerberas against a blue background, blue being the complementary colour of orange. The use of the complementary colour for the backdrop makes the orange flowers seem to leap out from the image. I then substituted a pink background which is more harmonious, pink being on the same part of the colour circle as orange, and the contrast between the gerberas and their background is much less marked.

Photographing Flowers

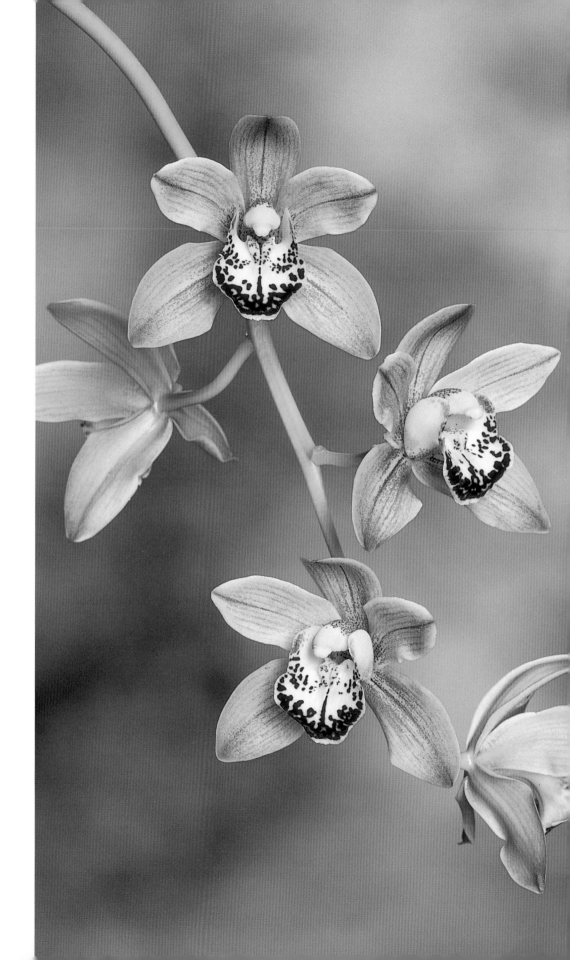

You may prefer to have a natural-looking background, so that it is not so obvious that your photograph was taken in studio conditions. One way of achieving this is by placing a vase of foliage behind the flower you are photographing (but far enough away that you can throw it out of focus!). Alternatively you can create a background by photographing some foliage or grass on print film, using your widest aperture and throwing everything completely out of focus. Take a few different subjects and bracket your exposures. When you get the resulting prints, pick out one or two which you think have a nice soft blend of different shades of green, without any hard lines or shapes, and have enlargements made of them, 18 x 12in (46 x 30.5cm) or maybe larger, on matt paper. (This may cause you to get some funny looks from the processors, but persevere!) These large prints can then be positioned behind your cut flower, and will look like a natural out-of-focus background. Just take care that there is no light reflecting off the print – this is why it's better to have the prints made on matt rather than gloss paper.

ORCHID

This photograph was taken in my (extremely small!) conservatory, and there was no room to set up a natural background, so I used a print of out-of-focus foliage behind the flower.

Because the background was already out of focus and there was no wind, I could use an aperture of f/16 for sharp detail in the flowers without worrying about including distracting backgrounds or having movement in the flowers

Backgrounds

9

SOFT FOCUS

Adding a touch of soft focus to your photographs immediately takes them one step away from reality, giving them an ethereal, impressionistic feel. Soft focus should not be used in every photograph, however – some flowers or scenes will lend themselves to this technique more readily than others. At first, take photographs both with and without soft focus, and soon your experience will begin to tell you where it is going to work and where it is not. As a general rule of thumb, it is more pleasing with light-coloured flowers than with dark; and it works well where all the elements in the picture lend themselves to a feeling of softness, but not so effectively where there are also 'harder' elements in the image, such as a rock or a mountain backdrop to a field of flowers.

For instance, I was once travelling in Andalucia when I came upon one of the most wonderful and colourful displays of wildflowers I have ever seen. Wildflowers are no longer common in Andalucia, as many farmers use herbicides to keep their olive groves 'clean'. This particular meadow had only a few very small olives in it, and the flowers had been allowed to flourish. Behind the meadow was the grey backdrop of the mountains of the Sierra Gorde.

WILDFLOWERS, ANDALUCIA

I loved the contrast between the barren mountainside and the lush flower meadow and did not want to use a soft focus filter as I felt it would have detracted from this. However, when photographing the flowers on their own, I liked the results both with and without a soft focus filter. The soft focus filter gave a rather impressionist effect.

Soft focus

No filter

(Above) no filter; (below) with soft-focus filter.

There were clearly two main ways to approach photographing this fabulous meadow. One was to photograph the whole scene, enjoying the contrast between the colourful lushness of the flowers and the stark grey rock behind. The other was to photograph only the flowers. For the photograph of the entire scene, soft focus seemed wrong, as it lessened the impact of the contrast between rock and flowers. For the images of flowers only, however, I liked the results both with and without soft focus; a touch of soft focus added an impressionistic feel to the pattern of vibrant colour.

ROADSIDE FLOWERS, TUSCANY

The first of these photographs was taken without a filter, and a subtle soft-focus filter was used on the second photograph. The effect is quite delicate, and it is not overpoweringly obvious that a filter has been used.

This image was taken when a cloud passed over the sun (overcast light being much more flattering to the subject than harsh sunlight). To counteract any blue colour cast on the film, I added an 81B warm-up filter

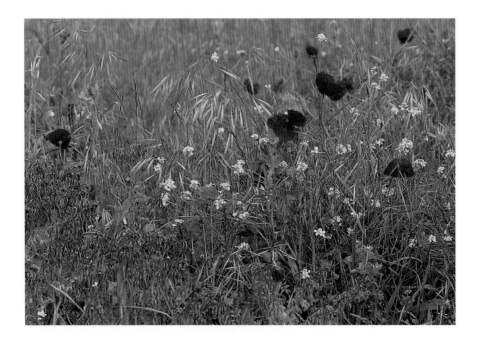

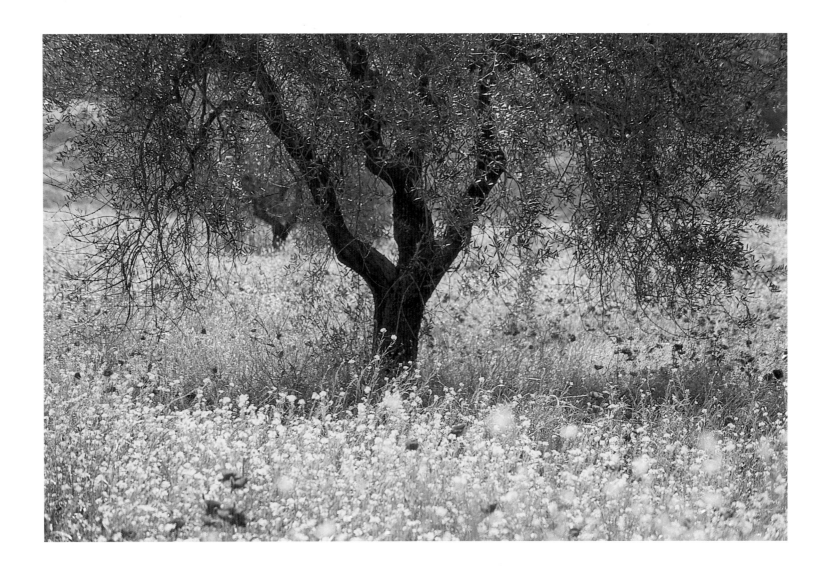

OLIVE TREE AND WILDFLOWERS *(above and right)*

The first of these photographs shows the olive tree surrounded by flowers, but doesn't have a great deal of atmosphere. To make the second photograph I used some flowers very close to the camera to create a wash of yellow, added a warm-up filter, and also tightened up the composition to create a much more satisfying image.

In the second photo (right), I shot through some yellow flowers in the foreground. Because they are so close to the camera, they are completely out of focus and appear as a painterly yellow wash.

To create an image like the one on the right, you will need a telephoto lens of 100mm or longer and an aperture of around f/5.6 or f/8

Shooting through foliage

One method I enjoy for creating a soft-focus type of effect is to shoot through flowers or grass extremely close to the lens, focusing on a flower further away. This method works best with a medium to long telephoto lens.

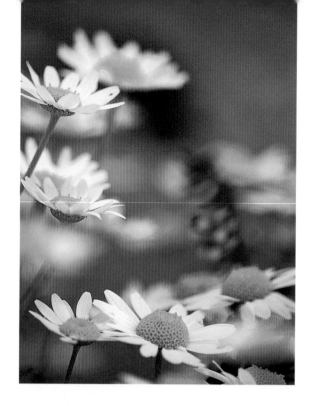

Opposite is a pair of photographs of the same group of wildflowers, one taken 'straight', and the other taken with a few blades of grass held right against the lens. You can see that the grass is not identifiable as grass in the resulting photograph, but has merely created a slightly softer effect, particularly on the flowers in the background.

If the flower you are shooting through is just a little further from the lens than in the previous example, you can use it to create a wash of colour. This is useful if there is something unsightly in the foreground that you want to hide, such as a patch of bare earth, but is also lovely as an effect in its own right.

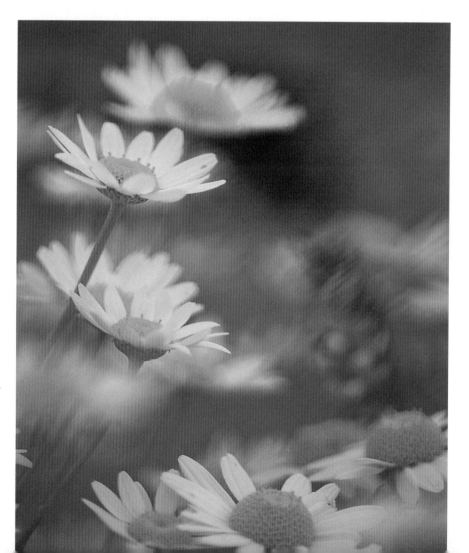

The first image is a 'straight' photograph of the flowers, while the second shows the same scene with a few blades of grass held in front of the lens.

An aperture of f/5.6 was used to soften the background flowers

Soft focus

In addition to the manufactured soft-focus filters, there are many ways in which you can make your own soft focus. One is to put a clear skylight filter over your lens, and smear a very tiny amount of Vaseline on it. The skylight filter will not affect the resulting photograph in any way, it is just used because you should not put Vaseline on the front element of your expensive lens! If you make horizontal stripes with the Vaseline, in the resulting photograph the stripes will appear vertical, and vice versa. Or you can just put the Vaseline in tiny dabs without creating a striped effect, and this will act in much the same way as a normal soft focus filter. You can see the effect of the Vaseline by looking through the lens, and make adjustments to the amount or distribution of the Vaseline until you are happy with the result.

Another method is to put a piece of ladies' stocking over the lens, held in place with an elastic band. The colour of the stocking will affect the result you get. And if you find yourself in a situation where you have no other means of making soft focus, you can always breathe on the lens – but then you have to work quickly before the misting effect evaporates!

Soft-focus filters

There are many different kinds of soft-focus filters available to buy. Some come in different 'strengths', ranging from a hardly noticeable softening effect to a real blurring; some have the same softening throughout, while others have clear centre spots to enable a part of the picture to be unfiltered and therefore sharp. I don't find these latter ones useful, as they assume that the sharp part of the picture will be in the centre, which is very limiting. The effect of the filters is to spread the highlights in the picture and to soften the sharp contours of the subject.

Soft focus with an autofocus camera

Beware of using a soft-focus filter when using an autofocus camera, as it may confuse the focusing mechanism, causing it to 'hunt' and be unable to find where it should focus. If possible, switch your camera onto manual focus. Assuming you are working with your camera on a tripod, it is better to focus before putting the filter on the lens, so that you can see clearly enough to make sure your point of sharp focus is where you want it to be.

Close-ups

One situation where I rarely use soft-focus filters is when I am photographing an extreme close-up, showing only part of a flower. In this case the depth of field will usually be absolutely minimal, so much of the picture will be 'soft' anyway because of the differential focus (see Chapter 4). Also a picture of this type will be all about colour, texture and form, and a soft-focus filter will detract from this.

Photographing Flowers

Andalucia in southern Spain is perhaps better known for its vast plantations of olive trees, but the area also produces almonds, and for a brief period in February the almond trees are covered in white and pink blossom, a wonderful foretaste of spring in an otherwise wintry landscape. The almonds are only grown in certain regions, and the trees in the various areas come into flower at different times depending on the climate, which can vary surprisingly within only a hundred miles or so. At the time when I visited, the trees in full blossom were in the Alpujarras region, to the east of Orgiva.

CASE STUDY 4: Almond blossom in Andalucia

When I first arrived, the contrast between the grey and drizzly English February day that I had left behind and the sloping mountain-sides covered with a delicate froth of blossom left my senses reeling. I spent some time just driving around and looking, taking it all in before I began to photograph. Once you start, the difficulty lies in translating your emotional impression onto film. The elements that stood out for me were the gracefully twisted black trunks around which floated soft clouds of snow-white and sugar-pink blossom. The sunlight seemed to make the blossom sing out with radiance. All this visual sensation was enhanced by the honeyed fragrance of the flowers, the welcome warmth of the winter sunshine, and the gentle hum of the bees. The reality that I saw was a subjective one. However, what the camera would record was the objective reality; that the trees were growing out of scrubby ground, with bare earth and some rock as well as some dead wintry grasses. The ground was also

Location:
Alpujarras region
of Andalucia, Spain

Time of year:
February

Camera:
Nikon F100

Film:
Fuji Velvia

Lenses:
80–400mm zoom +
500mm mirror lenses

Filters:
81B warm-up

The photograph right is a 'straight' view of the scene in front of me where I stopped to try to make a photograph.

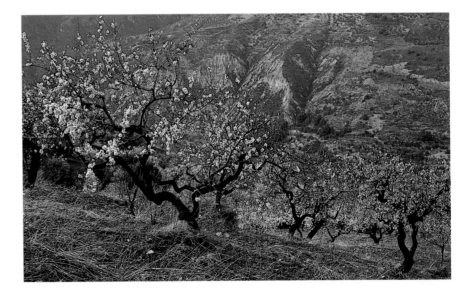

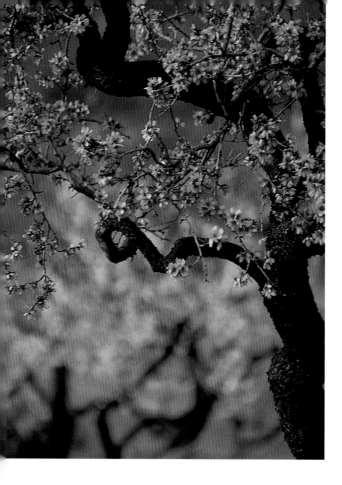

Harsh sunlight
What we might normally consider to be beautiful sunlight can actually be far too hard when taking photographs.

My first aim was to find a composition that excluded the rough, scrubby ground and included the twisted trunks as well as both pink and white blossom.

after maybe half an hour of looking. I liked it because it combined both colours of blossom, pink and white, and because it showed the graceful twisted trunks and branches of the almond trees. It also filled most of the frame with blossom and branches, and included very little of the ground between the trees. I also liked the way the twisted branches in the out-of-focus trees in the distance echoed the twist of the branch of the tree in the foreground. The only problem was that a tiny patch of the road on the other side of the almond grove was visible between the branches of the background trees. This would be very easy to put right with the aid of a computer – but there is always more satisfaction for me in getting a photograph right on the day and not having to doctor it afterwards.

I then changed lenses and used a 500mm mirror lens. I decided that in order to convey my subjective idea of the place, I would actually throw everything out of focus to obtain a very impressionistic result.

steeply sloping. The sunlight that was so good on the eye was actually creating huge problems with contrast, causing the white flowers to look almost harsh and hard.

The object of the exercise was now to bridge the gap between the subjective and objective realities of the scene. Fortunately there was some cloud in the sky, so I was able to compare how any particular view looked in sun or in overcast light.

The greatest difficulty was to find a composition which was pleasing and which excluded as much as possible of the scrubby nature of the ground. I moved around with my camera with a zoom lens attached, crouching down low, standing up, trying to find a combination of elements in the scene that I liked. The photograph above was one that I found

Mirror lenses

When you use a mirror lens, anything you focus on will be as sharp as with any other lens, but all out-of-focus highlights will appear as circles, often known as 'doughnut rings'. Right and over the page are some of the results of this approach.

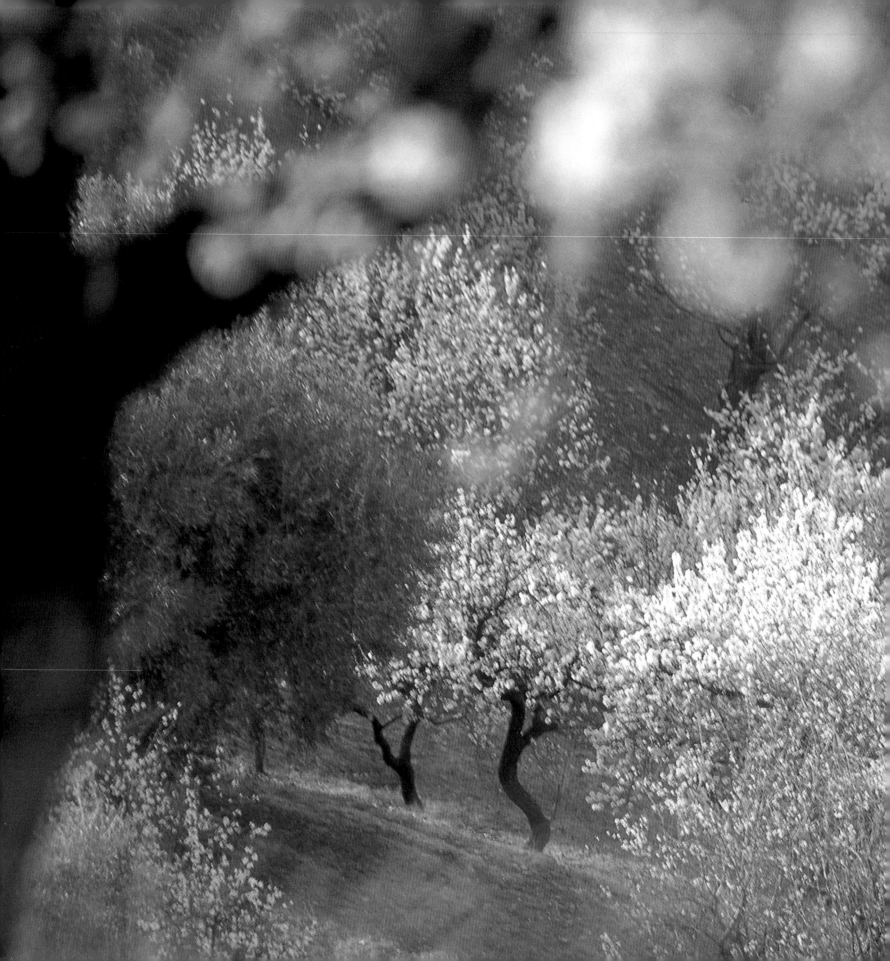

The picture above was taken using the mirror lens. When you compare it to the 'straight' photograph of the grove, you can see that it is starting to convey a much more personal impression of the place rather than just a record of it.

This is my final and maybe favourite image.

Once I found a composition that I liked, I moved the focusing ring in and out until the image had the right amount of sharpness and unsharpness. I wanted to go far enough out of focus that nothing was pin sharp, but not so far that the components of the scene lost their shapes, becoming unidentifiable.

I switched back to my zoom lens to take my final, and maybe favourite image of the day. This was taken at a wide aperture with the lens focused on the distant trees; the effect of this was to throw completely out of focus the blossom on the foreground branch which I used to frame the scene, creating a rather dream-like feel. This image appeals to me because it equates most closely to my subjective and emotional interpretation of the place; another person might see the place differently and so record it in a different way. The important thing is to come away with an image that is emotionally satisfying to you, so that when you return to it, it will evoke the feelings you had when you were there, blossom, sunshine, fragrance and all!

10

SPECIAL EFFECTS

A record photograph could be defined as a straightforward transfer of an image of an object via a lens and camera on to film. The resulting photograph is a simple record of the object, with no subjective vision added to it. Unless you are photographing for a specific documentary purpose, you will probably wish to add something to your photograph, to give your images an emotional content, and also a style of your own. It is a mark of many of the best-known photographers and painters that a viewer can look at one of their images and recognize who has created it, simply because it has the style of its author.

You probably won't achieve your style straight away, or even know at the beginning what you want it to be. It is only as you make your images over the years that you will notice your photography going in a particular direction – you will discover a tendency towards using a particular lens or filter, or that you respond more to a particular colour spectrum, or that you often choose an unusual angle on your subject, or that you have a preference for a certain type of subject in a specific kind of light.

When I began discovering photography I photographed everything and anything. After a short while I found that I much preferred natural subjects,

and concentrated more on landscape and flowers. As time went on I found that I wanted to get away from making a record photograph, however perfectly exposed and sharp it might be, and try instead to make more artistic images. Over the years there has been a lot of experimentation, and a lot of exposed film ended up in the bin along the way. However, I don't regard this as a waste, but as a necessary part of the learning process.

The various methods of getting away from reality have been discussed in the previous chapters – using differential focus, abstracting parts from the whole, softening the focus and creating soft washes of colour in the foreground or background. It is only as you experiment with different combinations of techniques that you discover what works for you. I have even found that throwing the whole image out of focus will sometimes work. Strangely it is just as difficult to take a successful out-of-focus image as a successful sharp one – all the considerations about composition, colour balance and so on are still equally applicable. Not every subject will work well with this treatment, and the lack of sharpness has to look intentional, and not as if it was done by mistake. However, there are some occasions where I feel this approach better conveys the emotional impact that a scene made on me when I saw it than a photograph with sharp detail would, such as with the image of almond trees, on the following page.

Developing a style

I don't think that development of your own style can or even should be forced. It is a natural development that occurs as you experiment with all the various approaches towards your image-making, and eventually choose the way in which you can best express yourself.

ALMOND TREES

In this photograph of almond trees in blossom, the out-of-focus treatment has made the blossom look much more soft and frothy than when it was sharply focused, and the shapes of the trunks are defined clearly enough to make it apparent what the subject is. The muted blues and greens in the background also become an integral part of the picture because the image is only about soft colour and shape.

I used my widest aperture when taking this photograph, so that the image I saw in my viewfinder corresponded exactly with the image that would result, and I could judge exactly the amount of 'unsharpness' that I wanted

This defocusing technique can be particularly fun with a mirror lens. Mirror lenses are telephoto lenses, usually of about 500–600mm, with a fixed aperture (usually f8). They are considerably cheaper than the equivalent length conventional telephoto lens, but the fixed aperture means that their use is sometimes limited. Because of the way they are made, any out-of-focus highlights appear as soft rings of colour, sometimes referred to as doughnut rings. I have greatly enjoyed taking photographs with a mirror lens where everything is out of focus. Once you have found your subject, move the focusing ring slowly in and out and see how the image changes.

DEFOCUSING

Beware that, while you are concentrating on the amount of defocusing you want on your main subject, you don't allow something either in front of or behind your subject to come into sharp focus. The technique works best with subjects that have a clearly defined shape, so that they are still recognizable even when they are only represented by circles and streaks of colour.

DAFFODILS (left) and TULIPS (below)

Familiar flowers with well-defined shapes work well with the mirror lens technique.

Working with a 500mm mirror lens at its fixed aperture of f/8, I turned the focusing ring in and out until I found the effect that I wanted

It is quite difficult to define the term 'special effects', as it could be used to encompass any method of altering the image so that it appears differently on film from the way it did in reality. There are, for instance, a whole range of special effects filters available, but sadly at least 90% of these are not likely to be helpful to your flower photography – it's hard to imagine for instance how one might use graduated filters ranging from tobacco through violet to crimson to produce a pleasing flower photograph. The filters which you are most likely to enjoy using, apart from the warm-up and polarizing filters which are not generally considered as special effects, are the various soft-focus filters available – these have been discussed in more detail in Chapter 9. Other special effects are due more to what you do with your equipment than to buying extra gadgets to add to it. These include camera movement, subject movement, multiple exposures and montages.

Camera movement

Camera movement is exactly as its name implies – the camera is moved during the time that the shutter is open. You will need to use a longish shutter speed for this – anything shorter than 1/60 second is less likely to produce a good result. I usually find that the best results are obtained with speeds of 1/15 or 1/8. The camera can be moved vertically, horizontally, diagonally, or even round in circles. You need to pre-visualize to some extent if you can the effect you are hoping to achieve. Imagine that the colours in the scene before you are going to be pulled across the image area in whichever direction you choose. Begin moving the camera before you open the shutter, then press the shutter release as you continue the movement smoothly until you hear it close again. Try a range of different shutter speeds for any one subject to see which one works best.

POPLAR TREES WITH YELLOW FLOWERS

In this pair of photographs of a poplar plantation with some yellow flowers growing at the base of the trees, the first photograph I made is a 'straight' one (left). I decided to exclude the tops of the trees and the sky as to include them would have weakened the pattern created by the tree trunks. However, I didn't feel completely satisfied with this image – it seemed rather static. By excluding the tops of the trees I had indeed emphasized the pattern, but I had also lessened the feeling of the trees soaring upwards. I decided to try panning, and because of the vertical nature of the trees, a vertical movement of the camera seemed the obvious choice. To me the second image (right) is much more satisfying than the static one.

I find that a shutter speed of between $^1/_{15}$ and $^1/_4$sec is usually best for panned shots

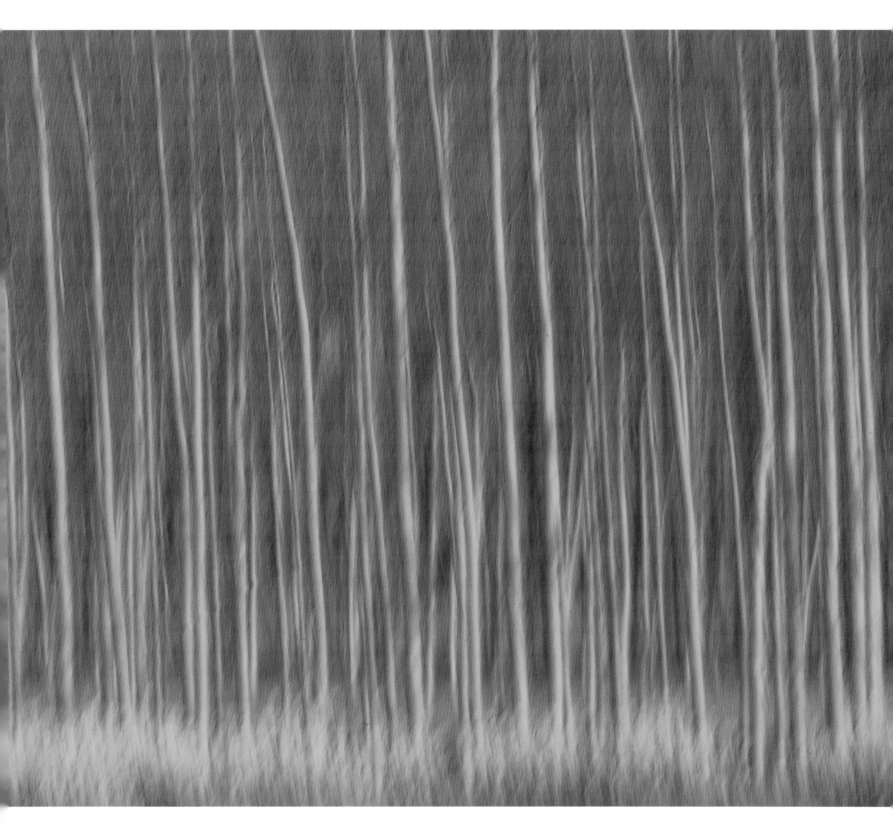

Subject movement

Subject movement is the opposite of camera movement, in that the camera is kept still while the subject is moving. You will need to have your camera on a tripod for this technique, and it will work best on a windy day when the flowers and grasses are swaying in the breeze. Again you will need a fairly long shutter speed, anything up to several seconds depending on the strength of the wind and the consequent amount of movement in your subject. The flowers will then paint their colours across your film as the wind blows them. This can also be effective if there is a static element, such as a tree trunk or a rock, in your image, and then the sharpness of this contrasts well with the soft blurred movement of the flowers.

Multiple exposures

Multiple exposures can be a fun technique to try with flowers. Most modern SLRs have a multiple exposure facility, which allows you to take as many photographs as you want without advancing the film, or in others words, to put as many images as you want on the same frame of film. In this way you can gradually build up your image out of many different ones. Of course this means that you will have to adjust your exposure accordingly, otherwise you will end up with a completely overexposed, blank piece of film! You can adjust the exposure either by changing the film speed setting on your camera, or by using the exposure compensation button. If you choose the film speed option, you set your camera as if you were using a faster film than

LAVENDER

In a strong breeze an exposure of ½ second was enough to show movement in this lavender.

You will need to have your camera on a tripod in order to take shots showing subject movement

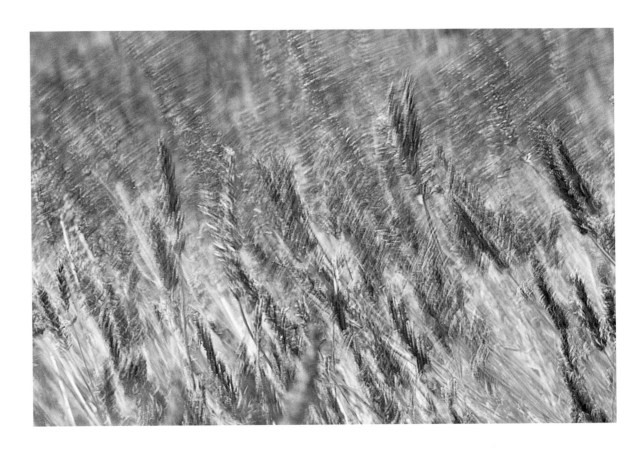

Photographing Flowers

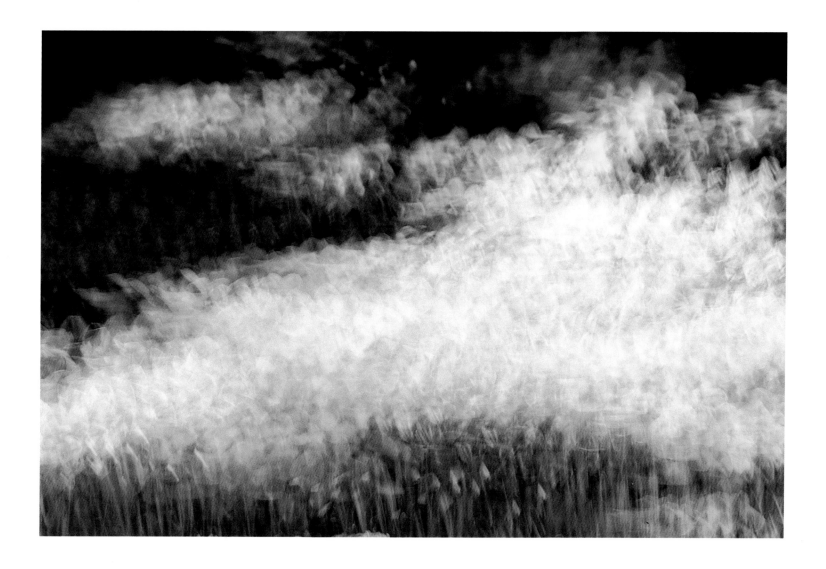

the one you are in fact using, increasing the speed of the film for each extra image you are making on a single frame – for instance, if your film speed is 100, you would rate it at 200 for two exposures, 400 for four exposures and so on. If you use the exposure compensation button to adjust your exposure, and want to make two exposures on a single frame, dial in minus 1; for four exposures dial minus 2, for eight exposures dial minus 3, and so on.

DAFFODILS

This photograph of daffodils was made using nine exposures on the same frame of film. In order to make the exposure correct I dialled in minus 3 on my exposure compensation. Although the formula gives eight exposures for minus 3, I quite often add a ninth exposure as I prefer my images to be on the light side rather than dark.

To achieve this kind of effect, hand hold your camera and move it very slightly between each exposure

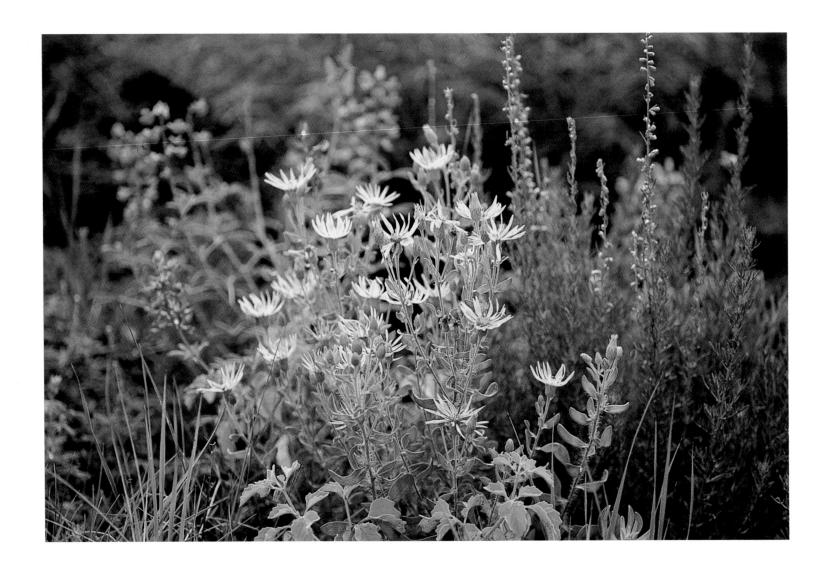

MULTIPLE EXPOSURES

There are two main ways in which you can create
multiple exposure photographs. One is to make multiple
images of the same subject whilst hand holding your
camera and moving it just very slightly between each
exposure – the result will be that each image is slightly
out of register with the others, creating a tapestry effect.
The other approach is to put your camera on a tripod
and take two or more images of the same subject, with
one or more in sharp focus, and one or more out of focus.
This creates a soft halo effect around a sharp subject.

WILDFLOWERS, NEW MEXICO

The first photograph is a straight version of this group of
flowers, and the second was a multiple with nine exposures,
moving the camera slightly between each exposure.

Special effects

Montage

Another technique is a montage, or slide sandwich, which is created when you take two separate images and then, after processing, sandwich them together in one slide mount. Again, you will have to adjust the exposure, because if you put two normally exposed images together, the result will be far too dark. As a guide, each image should be overexposed by one stop. However, you may after some experience decide that you want one of the images to be more dominant than the other, in which case that image should be closer to the normal exposure, and the other image will be even more overexposed. There are two main approaches to montages – the first is to take one frame in sharp focus and one frame out of focus, which creates a similar effect to the multiple exposure described above. The other is to photograph two different subjects and sandwich them together – for instance a silhouette of a tree on one frame can be sandwiched with a sunset sky on another frame.

Montaging

If you like the technique of montaging, it is worth building up a file of images which can be sandwiched together and experimented with on long winter evenings!

Straight photograph

With soft focus filter

Photographing Flowers

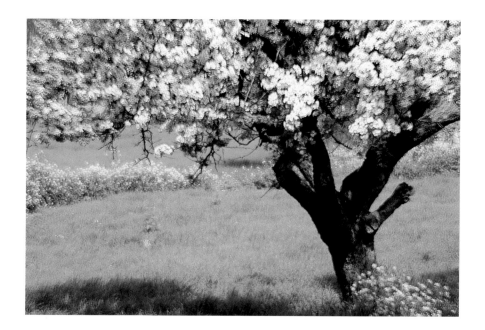

Double exposure

TREE IN BLOSSOM

This set of photographs shows the different results obtained by using a soft-focus filter, creating a double exposure and making a montage. Both the double exposure and the montage were made with one exposure in sharp focus at f16 and the second defocused at f4.8; however, you can see that the two techniques produce quite different results. Montages are more contrasty and almost have a three-dimensional effect.

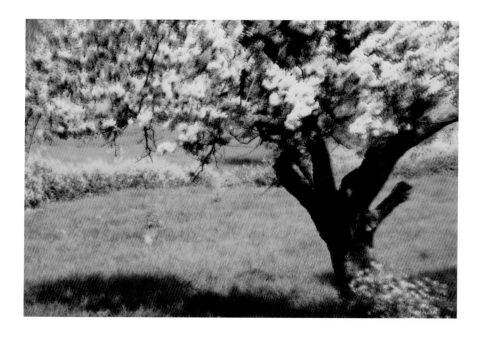

Montage

Computer manipulation

Of course many more options for altering your image are available if you use a computer – but that would be the subject of another book. The techniques described here are by no means an exhaustive list. They are also not ends in themselves but the means to an end – the end being your expression of yourself and your emotional response to a flower in the image that you create of it.

Index of photographs

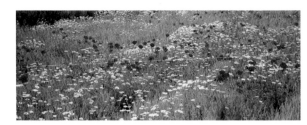
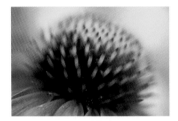
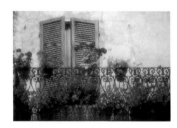
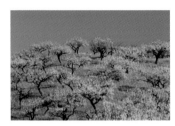
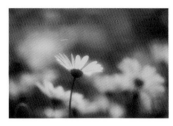
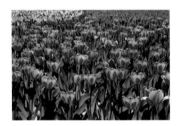
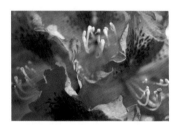
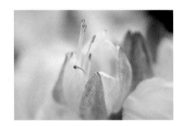
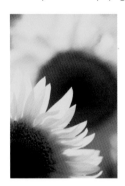
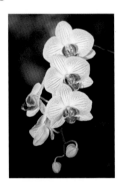

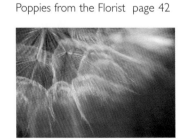
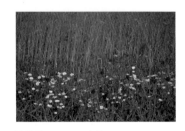

Poppies page 63

Lavender page 64

Peony page 66

Peony page 68

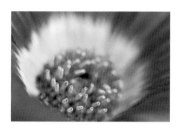

Arctatis page 70

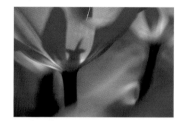

Tulips page 73

Rose and Painted Wall
page 74

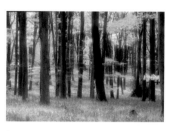

Bluebell Wood page 75

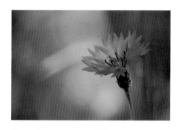

Cornflower page 77

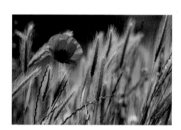

Poppy page 78

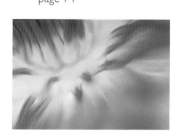

Water Lily page 81

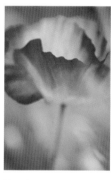

Poppies on an
Allotment page 83

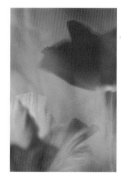

Poppies on an
Allotment page 84

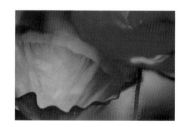

Poppies on an Allotment
page 85

Bluebells page 89

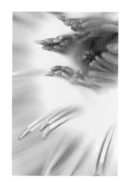

Water Lily page 91

Index of photographs

| 149 |

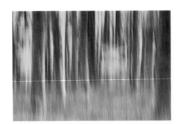

Bluebell wood page 92

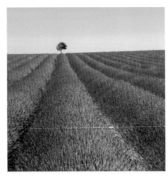

Lavender Field, Provence page 97

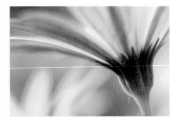

Water Lily page 99

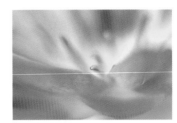

Osteospermums page 101

Tulips page 103

Namaqualand Daisy and Rock
page 105

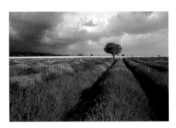

Lavender Field, Provence
page 106

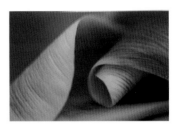

Tulip Petals page 108

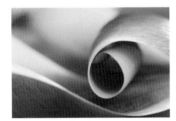

Tulip Petals page 109

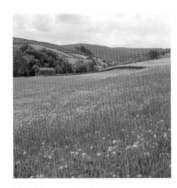

Wildflowers, Swaledale
page 112

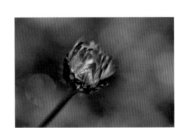

Daisy page 113

Wild Flowers, Namaqualand
page 115

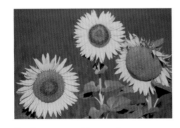

Sunflowers and Lavender
page 116

Peony page 117

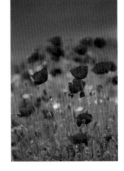

Wild Flowers, Umbria
page 118

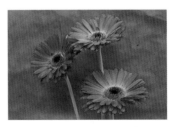

Orange Gerberas page 120

Photographing Flowers

Index of photographs

Acknowledgements

My thanks go to my husband Richard and to my parents for all their support and for looking after things at home when I went away photographing; and to Sylvie for holding the fort at the office during my absences. Also to everyone at GMC, especially Clare Miller who edited this book, Gilda Pacitti who designed it, and Paul Richardson for having faith in me. Many thanks too to Charlie Waite for his encouragement throughout.

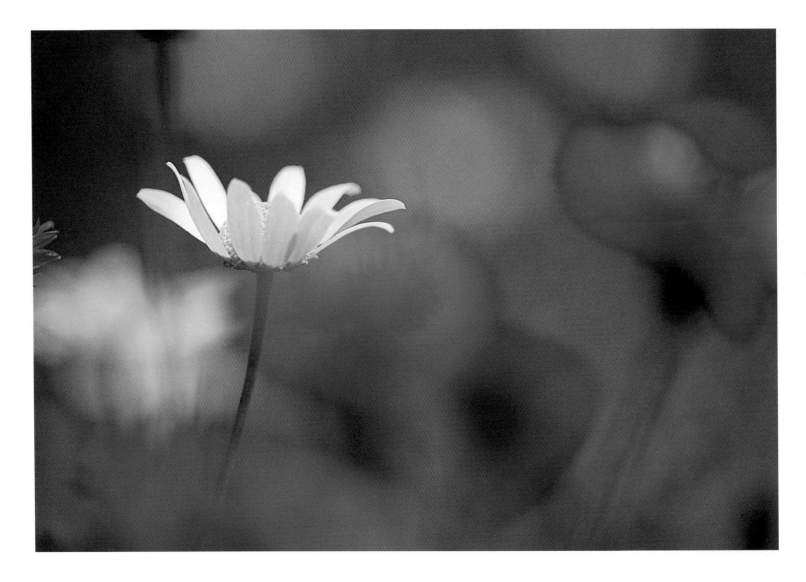

Index

Page numbers in *italic* refer to captions

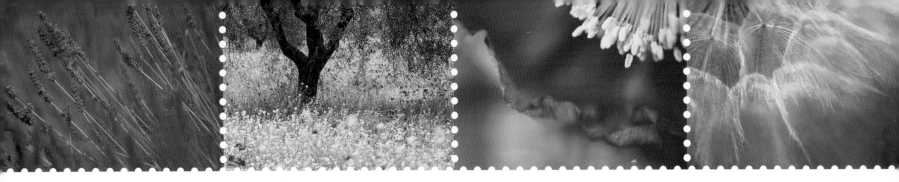

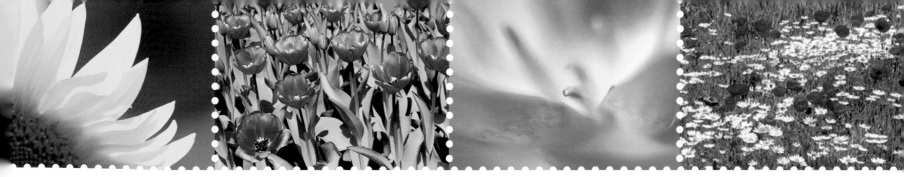

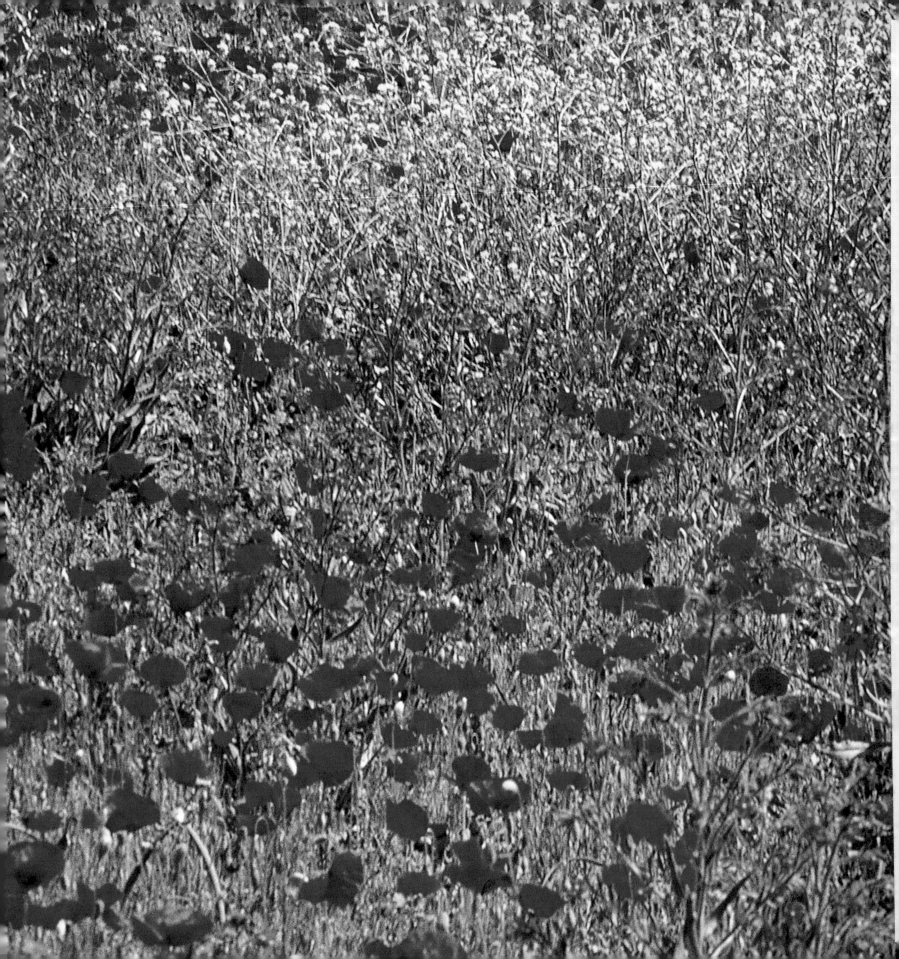